ARTS AND ENTERTAINMENT'S
TRICKIEST
QUESTIONS

ALSO BY PAUL KUTTNER

FICTION

The Man Who Lost Everything
Condemned
Absolute Proof
The Iron Virgin

NONFICTION

History's Trickiest Questions

ARTS AND ENTERTAINMENT'S
TRICKIEST
QUESTIONS

 402

Questions That Will Stump, Amuse,
and Surprise

PAUL KUTTNER

AN OWL BOOK / HENRY HOLT AND COMPANY / NEW YORK

Henry Holt and Company, Inc.
Publishers since 1866
115 West 18th Street
New York, New York 10011

Henry Holt® is a registered
trademark of Henry Holt and Company, Inc.

Library of Congress Cataloging-in-Publication Data
Kuttner, Paul.
Arts and entertainment's trickiest questions : 402 questions
that will stump, amuse, and surprise / Paul Kuttner. — 1st ed.
 p. cm.
 "An Owl book."
 1. Arts—Miscellanea. I. Title.
NX67.K88 1993 92-30822
700—dc20 CIP
 ISBN 0-8050-2384-4

First edition—1993

Designed by Katy Riegel

Printed in the United States of America
All first editions are printed on acid-free paper.∞

1 3 5 7 9 10 8 6 4 2

To the memory of
Margarete and Paul, my parents, and
Annemarie, my sister,
and also to
Stephen, my son,
and to
Ursula Fraenkel and Ilse Jochimsen

CONTENTS

FOREWORD

When readers of my last book, *History's Trickiest Questions,* wrote to ask me if there is a similar volume available with tricky questions about the movies or music or literature, all I could point them to were the countless trivia quiz books that consisted mainly of questions such as: Who were the stars of *Gone With the Wind*? In what town is Leonardo da Vinci's *Last Supper* exhibited? Certainly these questions are legitimate and educational, but far too tedious and dusty with old age for my tastes. So I decided to use my tricky question format to create a guessing game about the four facets of the arts and entertainment world—Stage and Screen, The Literary World, Music, and Fine Arts—that was surprising and entertaining and at the same time informative. Not only did I want to enlighten and challenge the reader in a field in which he or she might excel or have a passion,

FOREWORD

I wanted the questions and answers to be fun and crafty and . . . well, *artful*. So in the course of two years of research and double- and triple-checking, I came up with just over 400 such questions, meant to amuse, stump, and entertain readers of every age.

One of the things that delighted me most about *History's Trickiest Questions* was its success in general bookstores as well as in classrooms—from junior high on up through graduate school. Now, not only do I get mail from teenagers who enjoy stumping their "know-it-all" friends, I hear from their parents and professors as well!

Try these on for size. In the motion picture category: Why couldn't the most famous movie capital on earth have existed without Daeida Wilcox? Are you a cognoscente of music? What great twentieth-century composer was commissioned to write some ballet music for elephants? Know everything about art? What then, do we mean by the size of a painting, if we are not referring to its height or its width? And for your know-it-all friend who's a bookworm: What famous novelist is buried in two different places?

I trust you'll find something in here to pique your curiosity no matter what your artful passion is—from the index alone you can see there's a "cast of thousands" to learn about. Enjoy!

—Paul Kuttner
January 1993

QUESTIONS

STAGE AND SCREEN

☞ Q 1.

One of the Oscar-winning stars of the 1946 Hollywood motion picture *The Best Years of Our Lives* was not an actor but an American soldier, Sergeant Harold Russell (b. 1914). He had steel hooks instead of hands in the movie because his hands had been blown off on D-Day. Where was he when these wounds were inflicted?

☞ Q 2.

Who is the famous actress who was christened Maria de Lourdes Villiers, whose godmother was gossip columnist Louella Parsons (1881–1972), who has acted with the Royal Shakespeare Company in England, and who now has many children?

☞ Q 3.

When Adolf Hitler (1889–1945) heard that Albert Einstein (1879–1955), who was Jewish, was the guest of honor at the world premiere of Charlie Chaplin's *City Lights* on January 30, 1931, the future German dictator

turned his wrath for all time on Chaplin (1889–1977). As with Einstein, Chaplin's "Hebraic" features were emphasized in the National Socialist press, and the movies of "the little Jewish acrobat," as he was called, were later banned in Nazi Germany. Can you find the lie in the above that was spread throughout Nazi Germany and other parts of the world?

☞ Q 4.

Who majored in architecture at Princeton University, where he met stage director Joshua Logan (1908–1988), went on stage without ever taking an acting lesson, and eventually became one of the world's most popular movie stars? A few hints: He started in a Vitaphone film in 1934, made nine movies in 1936, and won an Oscar that stood for twenty years in the window of his father's hardware store in Indiana, Pennsylvania.

☞ Q 5.

Why was Daeida Wilcox indispensable to Hollywood, California?

☞ Q 6.

In what extremely popular movie, set during the 1930s, was the state of Israel shown to exist already? (Israel was founded in 1948.)

☞ Q 7.

What famous actor was replaced by W. C. Fields (1879–1946) in the part of Mr. Micawber in George

STAGE AND SCREEN

Cukor's (1899–1983) screen version of *David Copper-field* (1935) because he didn't like the part? Hint: It was the same actor who a few years earlier starred in a partially finished, never released motion picture based on a twentieth-century novel.

☞ **Q 8.**

What previously little-known actress won an Oscar for playing the title role in a widely acclaimed movie about the Second World War—a role Norma Shearer (1902–1983) had turned down as being too mature for her?

☞ **Q 9.**

What famous English actress, who was herself frail and terrified of contracting tuberculosis, saved John Gielgud's (b. 1904) life when he accidentally stepped into the deep end of her swimming pool in Hollywood in 1964? (He had never learned to swim.)

☞ **Q 10.**

Why did Laurence Olivier (1907–1989) film *Hamlet* (1948) in black and white?

☞ **Q 11.**

Nobody noticed it—not the director, not the film editors, not the head of the studio. Yet, accidentally captured on the sound track of a well-known movie musical during one of its most popular numbers was the shout of an unknown, unseen onlooker. What did he cry out to the singer?

QUESTIONS

☞ Q 12.

According to the German film *Der Kaiser von Kalifornien* (*The Emperor of California*), which president admitted California to the Union in 1847?

☞ Q 13.

Can you point out an anachronism in the 1939 motion picture *Gone With the Wind*?

☞ Q 14.

Why did Alfred Hitchcock (1899–1980) send out Christmas cards with all the letters of the alphabet on them except the letter *L*?

☞ Q 15.

What movie director worked for MGM longer than any other? Some other facts about him: He was made a Commander Nationale of the Legion of Honor in France; Lana Turner (b. 1920) said she never acted better than under his direction; he worked as a stage and costume designer for *Earl Carroll's Vanities* and a *Ziegfeld Follies* production in 1936; he also worked as a designer at Radio City Music Hall in New York.

☞ Q 16.

When Charlie Chaplin (1889–1977) first arrived in the United States in 1910 to tour with the Fred Karno troupe

of actors, what actor, soon to become famous himself, roomed with him?

☞ **Q 17.**

On whose gravestone does this epitaph appear: "On the whole, I'd rather be in Philadelphia"?

☞ **Q 18.**

Who was the ailing movie star whom Betty Hutton (b. 1921) replaced in the title role of *Annie Get Your Gun*?

☞ **Q 19.**

Do you know on which two occasions Vivien Leigh complained about her costar's breath?

☞ **Q 20.**

What was the first film that showed the bombing of London and the city going up in flames, as well as planes attacking one another in midair? When was it made?

☞ **Q 21.**

Name the actor, born in Lemberg, Austria, in 1895, who, when he came to the United States at the age of twelve, changed his name by turning his first name into his last name. He went on to win both an Oscar and a Tony, twenty years apart, for impersonating famous real-life people.

☞

☞ Q 22.

What composer wrote the only three musicals that ran more than 1,500 performances each after their Broadway openings?

☞ Q 23.

In *Mr. Smith Goes to Washington,* James Stewart (b. 1908), who plays the part of a United States senator, delivers a filibuster on the Senate floor during which his voice grows increasingly hoarse, almost to the point of losing it. How did he achieve this effect?

☞ Q 24.

When *South Pacific* was first performed, how long did it run on Broadway? How long did *Sweet Charity* and *The Boy Friend* run on Broadway when they first opened?

☞ Q 25.

Who invented the trucking shot (a camera shot that is filmed from a moving dolly or another vehicle)?

☞ Q 26.

"GENUINE CLASS" is an anagram of the name of a famous actor who is widely believed to have this quality. Who?

STAGE AND SCREEN

☞ **Q 27.**

Did Orson Welles (1915–1985) direct any movies before *Citizen Kane*?

☞ **Q 28.**

When was the first time a mother-daughter team appeared on stage in J. M. Barrie's *Peter Pan* (1904 premiere)?

☞ **Q 29.**

Who played the piano and sang *As Time Goes By* in the 1943 movie *Casablanca*?

☞ **Q 30.**

What do the motion pictures *Sleuth* (1972) and *Give 'Em Hell, Harry* (1975) have in common?

☞ **Q 31.**

How much money did James Cagney (1899–1986) get for playing George M. Cohan (1878–1942) in *The Seven Little Foys* in 1955?

☞ **Q 32.**

What became of Asta Nielsen, who was born in 1881 and was Europe's first female superstar of the silent cinema?

QUESTIONS

☞ **Q 33.**

Who said to whom: "I'd wring your neck, if you had one"?

☞ **Q 34.**

Whatever became of Pearl White (1889–1938), star of the famous serial *The Perils of Pauline*?

☞ **Q 35.**

What do Spencer Tracy (1900–1967), James Dean (1931–1955), and Peter Finch (1916–1977) have in common?

☞ **Q 36.**

What 1938 American play was unanimously panned on its try-out in Boston but when it opened, almost unchanged, on Broadway for a three-week engagement became a hit, garnering nine rave reviews and a Pulitzer Prize? The play eventually became an American classic—one of the most widely imitated theatrical works of the twentieth century.

☞ **Q 37.**

What movie studio uses a golden celluloid wreath as part of the emblem that appears at the start of its pictures?

STAGE AND SCREEN

☞ **Q 38.**

Was the Michael Powell film *Black Narcissus* (1947) with Deborah Kerr (b. 1921), a story that is set in the lush countryside of the Himalayas, actually shot in India? If not, where?

☞ **Q 39.**

What was the only review of a motion picture ever to be entered into the pages of the U.S. Congressional Record?

☞ **Q 40.**

What movie star interrupted his motion picture career for about four decades and then won an Oscar on his first try when he returned to the movies?

☞ **Q 41.**

The financial backers of this 1947 British film, which introduced a new star with flaming red hair and went on to become a great critical and popular success, had thought so little of this motion picture that they did not even give it an official London premiere. What was the title of the movie, and who was its star?

☞ **Q 42.**

Who started in show business at the age of four, and, by the time he was fifteen in 1932, was the second-highest-

paid child performer (after actor Jackie Coogan)? In
1966, the *Guinness Book of World Records* listed him as
the highest-paid orchestral musician in the world, mak-
ing $1,500 a week.

☞ **Q 43.**

How did a raging pneumonia and a 102-degree fever
save Elizabeth Taylor's life?

☞ **Q 44.**

Maria Augusta Kutschera, who was orphaned at the age
of seven, wanted to become a nun even though her
court-appointed guardian was extremely anti-Catholic.
She did join a convent, but eventually she married a
highly decorated U-boat commander of the First World
War, and many years later her life story became the
basis of a celebrated Broadway musical and the movie
made from it. Who was she?

☞ **Q 45.**

How did the two great cowboy actors Tom Mix
(1880–1940) and Buck Jones (1889–1942) die?

☞ **Q 46.**

In one scene of the film version of *Gone With the Wind*,
Scarlett O'Hara can be seen hiding under a bridge while
a wagon is passing overhead, and in another scene her
hand can be seen withdrawing a revolver (with which
she later shoots a Union soldier) from a chest of draw-

ers. What was the name of the actress who appeared in those scenes?

☞ **Q 47.**

What famous cowboy actor had never been on a horse until 1935, when he was almost forty, and then went on to make sixty-six cowboy movies?

☞ **Q 48.**

Name the famous American ballerina who was married first to a great concert pianist and then to a well-known Hollywood producer-director.

☞ **Q 49.**

In 1940, he was one of Universal Pictures' most profitable stars. In 1941, he was fired and never made a comeback. Who was he?

☞ **Q 50.**

What actor, who is part Cherokee, part Jewish, and part black, has played Hamlet, Macbeth, King Lear, and Othello (the latter many times in Norwegian); starred in O'Neill's *The Emperor Jones* at Stockholm's Royal Theatre; and was the male star in the original Broadway production of *Driving Miss Daisy*?

☞ **Q 51.**

Each of the following actresses has played a similar type of character, in different films: Marie Powers,

QUESTIONS

Alma Kruger, Ava Gardner, Merle Oberon, Gail Son-
dergaard, Bette Davis, Tallulah Bankhead, Irene
Dunne, and Flora Robson. What role do they have in
common?

☞ Q 52.

Each of the following actors has played a similar type of
character, in different films: Paul Henreid, Robert
Walker, Alan Curtis, Albert Bassermann, Cornel Wilde,
Jean Pierre Aumont, Richard Chamberlain, Trevor
Howard, Dirk Bogarde, and Tom Hulce. What role do
they have in common?

☞ Q 53.

What great American ballerina had more ballets choreo-
graphed for her by famous choreographers than any
other ballerina in the world?

☞ Q 54.

What very successful American playwright wrote forty-
one plays, but mostly in collaboration with other play-
wrights? What were some of his greatest hits?

☞ Q 55.

Whatever happened to the red slippers that Judy
Garland wore when dancing down the yellow brick road
in *The Wizard of Oz* (1939)?

STAGE AND SCREEN

☞ **Q 56.**

William Faulkner's first writing assignment when he went to work for MGM Studio in 1932 was a movie about wrestling for Wallace Beery (1889–1949). What kind of movies was Faulkner hoping to work on?

☞ **Q 57.**

When Shelley Winters (b. 1922) received an Academy Award for her performance in *The Diary of Anne Frank* in 1959, where exactly was the award presented to her?

☞ **Q 58.**

Name one actor and one actress who were acting in Hollywood movies before the First World War broke out and who were still acting in them seventy-five years later, in the late 1980s.

☞ **Q 59.**

What medical procedure did Marlene Dietrich (1901–1992) endure to further accentuate her beautiful, high-cheekboned facial structure?

☞ **Q 60.**

Allen Stewart Konigsberg is the real name of what famous motion picture actor, writer, and director?

QUESTIONS

☞ **Q 61.**

What is the well-known name of a legendary Hollywood actor born at the end of the nineteenth century in Omaha, Nebraska, under the name of Frederick Austerlitz? His father, an Austrian brewery worker and immigrant to the United States, had changed the family name during the First World War.

☞ **Q 62.**

During the Second World War, a group called "The Revuers" entertained at nightclubs across America. The members of the group were Adolph Green, Betty Comden, Alvin Hammer, John Frank, and Judy Holliday. Who was their frequent piano accompanist between 1939 and 1942?

☞ **Q 63.**

When Robert Benchley (1889–1945) was drama critic for the *New Yorker,* John Hay Whitney, who was considering investing in a play, sent him a copy of the script, asking for his opinion. Benchley replied, "I could smell it as the postman came whistling down the lane. Don't put a dime in it." What was the name of the play?

☞ **Q 64.**

Who won one Academy Award, was nominated for four others—*Boom Town* (1940), *Thirty Seconds Over Tokyo*

STAGE AND SCREEN

(1944), *The Asphalt Jungle* (1950), and *The Bad Seed* (1956)—and was married to Jean Harlow (1911–1937)?

☞ Q 65.

In what film did Alec Guinness (b. 1914) first appear, long before his first notable role as Herbert Pocket in David Lean's (1908–1991) film version of Dickens's *Great Expectations* in 1946?

☞ Q 66.

What actor became a real-life cowboy only *after* he began making movies as a cowboy star in 1911? He became a role model for the young John Wayne (1907–1979), who even imitated some of his mannerisms.

☞ Q 67.

What famous singer wrote a book that was never published but then adapted it for television where it became one of the most popular episodes of "The Virginian" series?

☞ Q 68.

Some consider her the greatest Giselle ever. Yet at the age of nineteen, she was threatened with total blindness and was bedridden for a year. She disobeyed her doctors, who forbade her to dance again, and, despite

cataracts and encroaching blindness, she danced and taught ballet for almost half a century. She is considered one of the greatest prima ballerinas of the twentieth century. Who is she?

☞ **Q 69.**

Who was the first famous female star to wear pants on the screen?

☞ **Q 70.**

What do the following actresses have in common: Carol Channing, Mary Martin, Ginger Rogers, Martha Raye, Betty Grable, Bibi Osterwald, Pearl Bailey, Phyllis Diller, and Ethel Merman?

☞ **Q 71.**

What world-famous actor, born in Brooklyn, won an Oscar for his performance in the screen version of a 1903 novel by Samuel Butler (1612–1680), yet was more famous for his role in a movie based on the novel *Professor Unrat* by Heinrich Mann (1871–1950)? He changed his nationality shortly before he died in 1950.

☞ **Q 72.**

How long was Greer Garson's (b. 1908) acceptance speech when she won the Academy Award in 1942 for her performance in *Mrs. Miniver*?

STAGE AND SCREEN

☞ **Q 73.**

What was the title of Dan Greenburg's novel on which Elvis Presley's (1935–1977) movie *Live a Little, Love a Little* (1968) was based?

☞ **Q 74.**

Who was the star of the German movie *The Four Companions (Die Vier Gesellen)*, which was filmed while she was pregnant in Hitler's Berlin in 1938? For her performance she received a Nazi medal, which she still had at the end of World War II. In her last motion picture (made for television), she portrayed a woman suffering from cancer while she was dying of cancer herself.

☞ **Q 75.**

Her maiden name was Apolonia Mathias-Chalupec. At seventeen she made her first movie, *Slaves of Sin*, in Poland. In 1935, Nazi propaganda minister Joseph Goebbels (1897–1945) put her on a list of suspected "non-Aryans," but Hitler (1889–1945) was so fond of her after seeing her German film *Mazurka* that he personally intervened on her behalf. At one time she had been Charlie Chaplin's fiancée, and she was living with Rudolph Valentino (1895–1926) when he died. Who was she?

☞ **Q 76.**

When Warner Brothers' *The Jazz Singer*, the historic first motion picture with sound, had its world premiere

in New York in December 1927, why didn't all three Warner brothers attend the performance?

☞ **Q 77.**

Before John Huston (1906–1987) chose Sean Connery (b. 1930) and Michael Caine (b. 1933) to play the leads in *The Man Who Would Be King*, based on Rudyard Kipling's (1865–1936) story, which other two actors had he hoped to cast?

☞ **Q 78.**

When the silent movie star John Gilbert (1895–1936) punched Louis B. Mayer (1885–1957) for saying, "Sleep with her! Don't marry her!" to what woman had Mayer been referring?

☞ **Q 79.**

What movie star, the greatest box-office draw of her day, died while watching a telecast of a movie starring one of her many lovers and directed by another?

☞ **Q 80.**

During the Second World War, U.S. Army photographer David Conover was ordered by his commanding officer to take promotional pictures of pretty women attaching propellers to model aircraft at Radioplane Corporation. These were the very first promotional pictures of one young woman who was destined to become one of the most photographed beauties of the twentieth century. Conover's commanding officer later was elected U.S. president. Who were they?

☞ **Q 81.**

In 1950, an actress won the Tony Award for her starring performance in a famous Broadway play, which later became a Broadway musical in the sixties under a different title. In the 1972 movie version of that musical, the star won an Oscar for her performance. Name the two stars and the titles of the play and the musical.

☞ **Q 82.**

What was especially striking during the Academy Award telecasts when it came to these three motion pictures: *Heaven Can Wait* (1978), *Reds* (1981), and *Bugsy* (1992)?

☞ **Q 83.**

One of the loveliest voices on film belongs to Adriana Caselotti, yet in one film she made, which has been shown all over the world for more than half a century, her name does not appear in the credits. What was it?

☞ **Q 84.**

Who is the only performer ever to be honored by three Academy Award nominations in a single year?

☞ **Q 85.**

The famous climactic scene in the film version of Lillian Hellman's (1907–1984) play *The Little Foxes* (1939) occurs when Regina Giddens (Bette Davis, 1908–1989) refuses to get her husband's heart medicine after he

suffers a sudden attack, thus forcing him to crawl up a flight of stairs leading to the second floor of their house. Since Herbert Marshall (1890–1966), the British actor playing the husband, had a wooden leg replacing the one he had lost during the First World War, how did he manage this seemingly impossible feat?

☞ Q 86.

Name these top movie stars who earlier made their living by: (1) stuffing groceries into bags at a supermarket in Van Nuys, California (and getting fired for inefficiency); (2) professional rat catching; (3) polishing coffins; (4) assisting in a barber shop; (5) operating an elevator; (6) mining coal in Pennsylvania.

☞ Q 87.

What popular movie star murdered his bride and then killed himself?

☞ Q 88.

Movie censors required this 1932 Broadway musical to add one letter to its title before allowing it to become an even more famous movie musical. What was its title?

☞ Q 89.

Which of the following actors does not fit into this group: Ray Milland, Walter Huston, Edward G. Robin-

son, Adolphe Menjou, Ray Walston, Claude Rains, and
Laird Cregar.

☞ Q 90.

When American films were shown in the former Soviet
Union their titles were invariably changed. Can you
guess the original American titles of the following three
motion pictures: (1) *The Journey Will Be Dangerous,* (2)
The Dollar Rules, (3) *The Fate of a Soldier in America*?

☞ Q 91.

For which director did Bette Davis (1908–1989) admit
doing as many as fifty "takes" per camera shot without
complaining? (She normally did no more than two or
three takes per shot.)

☞ Q 92.

What is the only major Hollywood movie with sound
that was shot in a matter of days, became a classic of its
genre for years to come, was a financial flop on its ini-
tial run, but won the Academy Award for best film of the
year?

☞ Q 93.

Right after the First World War, a famous movie star
refused to make any more slapstick movies, and pro-

ducer Mack Sennett (1880–1960) tore up her contract. Paramount offered her $25,000 a week and a $5,000 per week increase for the next five years, but she accepted United Artists' offer of a million dollars a picture. Today she is best known for a nostalgic movie about Hollywood made during the Korean War. Who was she?

☞ **Q 94.**

What movie star got his name from the way his mother called him home when he was out playing as a child?

☞ **Q 95.**

The daughter of an Australian musician, she played many parts opposite Laurel and Hardy in the early Hal Roach (1892–1992) comedies, including their first talkie. Who was she?

☞ **Q 96.**

Why did the comedian Harold Lloyd (1893–1971) prefer to be shot from the left side throughout his motion picture career, especially in the famous scene in *Safety Last* (1923) where he is seen clinging to the hands of a huge clock sixteen stories above street level?

☞ **Q 97.**

The serial queen of all time is still Pearl White (1889–1938) for her performances in *The Perils of Pauline,* the last episode of which was shot in 1923. Where was the series filmed?

STAGE AND SCREEN

☞ **Q 98.**

Who made this observation about a celebrity: "Wet she's a star, dry she ain't"?

☞ **Q 99.**

Can you name the years in which Hollywood released the two full-length features *Hey Hey in the Hayloft* and *Ants in Your Plants*?

☞ **Q 100.**

What television star wanted to do a TV series in which he would play a chauffeur and his screen wife a Hispanic maid, but then was persuaded by his real wife to change the professions of the TV couple? It turned out to be one of the most popular television shows in the United States and abroad, including South Africa where it was rated the favorite series.

☞ **Q 101.**

Name the star who first played the part of Billie Dawn in *Born Yesterday.* Do you know the original title of the play?

☞ **Q 102.**

Whom did Humphrey Bogart (1899–1957) replace as Rick Blaine in the movie *Casablanca*? Who was slated to replace Bogart if he also turned the part down?

QUESTIONS

☞ Q 103.

Which immortal twentieth-century showman gave the silent-movie star Joseph Francis Keaton, Jr. (1895–1966) the nickname "Buster" early in life? Hint: The showman's real name was Erich Weiss at birth and he was born either in Appleton, Wisconsin, or in Budapest, Hungary.

☞ Q 104.

Many critics thought that the best thing about Woody Allen's 1987 film *September* was Elaine Stritch's (b. 1926) performance as Diane. How did she happen to be cast in that part?

☞ Q 105.

Name the four stars who have won the "Grand Slam" of the Oscar, Emmy, Tony, and Grammy Awards.

☞ Q 106.

Who portrayed Richard Widmark (b. 1914) in the motion picture *Made in USA*?

☞ Q 107.

On its out-of-town tour, this 1967 musical was booed by audiences, panned by the critics, and on the verge of being withdrawn altogether. Then three songs were dropped, three others were added, half the first act was cut—and a hit was born. What was it?

STAGE AND SCREEN

☞ **Q 108.**

Rhett Butler's famous parting line to Scarlett O'Hara at the conclusion of the movie *Gone With the Wind* (1939) was, "Frankly, my dear, I don't give a damn." In Margaret Mitchell's novel (1936), did Rhett speak these same words to Scarlett?

☞ **Q 109.**

Who are the only two people represented in the baseball Hall of Fame in Cooperstown, New York, who are in no way connected with the game of baseball—not as players, coaches, managers, owners, designers of baseball stadiums, or as singers of the national anthem?

☞ **Q 110.**

What *two* Olympic champions starred in a Tarzan movie?

☞ **Q 111.**

For more than twenty years her sculptures and paintings were exhibited in Paris, and although George Bernard Shaw (1856–1950) considered her acting "childishly egotistical," almost a million people attended her funeral. Who was she?

☞ **Q 112.**

What do the following actresses have in common: Jeanne Moreau, Marlene Dietrich, Pola Negri, Louise Dresser, Elisabeth Bergner, Tallulah Bankhead, Hildegard Neff

(Knef), Viveca Lindfors, Bette Davis, and Zoë Caldwell? And what does Mae West share indirectly with these ladies?

☞ Q 113.

As many as three actors played the part of Iago in the Orson Welles (1915–1985) motion picture *Othello* (1952), but the performance in the final cut that is shown throughout the world is that of Michael MacLiammoir, the cofounder of Dublin's Gate Theatre. Who were the other two Iagos preceding him in this Shakespeare dramatization?

☞ Q 114.

How is it that in this film you watch a man step from the portico of a church in Torcello, an island in the Venetian lagoon, and in the next shot you see him in a Portuguese cistern off the coast of Africa? And what about the part in the same movie in which somebody kicks a man in Massaga only to be punched back in Orgete, which is about a thousand miles away? What is the title of this film?

☞ Q 115.

In 1978 public outcry saved this building from the wrecking ball; and soon after it was designated a landmark, it was restored to its original glory as one of the most popular places of entertainment on the east coast

STAGE AND SCREEN

of the United States. What is it? Hint: These groups were intimately related to this favorite tourist attraction: Reinhard and Hofmeister; Corbett, Harrison and MacMurray; and Hood and Fouilhoux.

☞ Q 116.

In 1992 *The Silence of the Lambs* won Academy Awards for its director, Jonathan Demme (b. 1944), its two stars, Anthony Hopkins (b. 1937) and Jodie Foster (b. 1962), and it received the ultimate award as best film of the year. How many times had that sweep of the four top categories been achieved before?

☞ Q 117.

The star opposite Greta Garbo in *Queen Christina* (1933) was her former lover John Gilbert. What performer did MGM first star opposite Garbo in this movie, and why was this actor replaced by Gilbert?

☞ Q 118.

The Greta Garbo film *Queen Christina* (1933) ends with the monarch leaving Sweden for Europe. It was with an intense feeling of relief that the Swedes watched her depart, and she actually left her native country in masculine attire under the name "Count Dohna" when she emigrated to Rome, Italy, in 1654. What is ironic about this assumed name as far as Greta Garbo is concerned?

QUESTIONS

☞ Q 119.

Do you know the name of the lead character in one of MGM's best-loved musicals, a character who bears the same name of one of this century's greatest tennis players? What star portrayed this character in what motion picture?

☞ Q 120.

What do the following show business stars have in common: Mickey Rooney, Zsa Zsa Gabor, Marie McDonald, Stan Laurel, Elizabeth Taylor, and Artie Shaw?

☞ Q 121.

Name the two most short-lived marriages in Hollywood history.

☞ Q 122.

Millions of moviegoers know many memorable lines of dialogue from *Casablanca* by heart. But few people realize that two famous lines were not in the final shooting script. What were those lines? How were they phrased originally? And who changed them?

☞ Q 123.

Casablanca had seven, *Tootsie* had eight, and *It's a Wonderful Life* had ten. What professional category do these numbers refer to?

STAGE AND SCREEN

☞ Q 124.

Margo Channing, as portrayed by Bette Davis (1908–1989) in *All About Eve* (1950), does not only appear in that great movie, but screen director Joseph L. Mankiewicz (b. 1909) gave this fictional character screen credit as a member of the cast in another motion picture. What is the title of this movie? And how can you explain that the Margo in this second film bears a likeness more to Joanne Woodward (b. 1930) than to Bette Davis?

☞ Q 125.

Did James Dean (1931–1955) ever appear on television before he became a movie star? What was ironical about his last TV appearance shortly before he was killed in an automobile accident?

☞ Q 126.

Motion picture director William B. Goodrich was formerly known under a different name as one of the world's most famous movie stars. That star had to change his name because he stood accused of a heinous crime. By what name was he best known and of what crime was he accused?

☞ Q 127.

Bedridden the last five years of her life, she never left her bedroom in that time and could only see the rooftops and the tips of trees from her window. When

she died alone while her grandson Peter discussed something with the maid next door she weighed less than eighty pounds. She had just suffered two strokes and had been unable to walk without the aid of a walker since October 1975 when she accidentally fell off the stage in Australia. She hated Hitler and wrote hate letters to Elizabeth Taylor (b. 1932), which she never mailed. On her last day, minutes before she died, her grandson Peter carried her into the living room, where she died moments after she whispered her daughter's name. Who was she?

THE LITERARY WORLD

☞ Q 1.

What is the third most widely used language in the United States, after English and Spanish?

☞ Q 2.

Before the eighteenth century, one-half of all printed books were published in which language?

☞ Q 3.

Who did William Faulkner (1897–1962), a winner of the Nobel Prize for literature (1949), think were the five best American writers of his time?

☞ Q 4.

Who said about another writer that he was a "glandular giant with the brains and the guts of three mice . . . the overbloated Li'l Abner of literature"?

QUESTIONS

☞ **Q 5.**

Did Harriet Beecher Stowe (1811–1896) invent the character of Uncle Tom in *Uncle Tom's Cabin* (1852)?

☞ **Q 6.**

Abraham Lincoln (1809–1865) credited Harriet Beecher Stowe with igniting the spark of the American Civil War when she wrote *Uncle Tom's Cabin.* What work did George Washington (1732–1799) credit with having "worked a powerful change in the minds of many men" and having been a driving force behind the American Revolution?

☞ **Q 7.**

What woman had close relationships, at various times, with the philosopher Friedrich Nietzsche (1844–1900), the poet Rainer Maria Rilke (1875–1926), and the founder of psychoanalysis Sigmund Freud (1856–1939)?

☞ **Q 8.**

What famous English writer and poet was reported killed in the battle of the Somme in 1916?

☞ **Q 9.**

What enormously popular turn-of-the-twentieth-century German novelist wrote many of his more than seventy books while serving prison sentences for theft? Ein-

stein said of his works, "My whole adolescence stood under his sign." Hitler reread most of his novels after becoming Chancellor of Germany and claimed he was his favorite author. Albert Schweitzer considered "much of his work imperishable." Hermann Hesse wrote that he was "the most brilliant example of an elemental form of literature." His works have been translated into many languages. How well is he received in the United States?

☞ Q 10.

How successful was Nathanael West's (1903–1940) classic study of Hollywood, *The Day of the Locust,* when it was first published in 1939?

☞ Q 11.

What American author was so distracted by the news that one of his best friends, also a famous writer, had just died that he drove through a stop sign, causing an accident that proved fatal for him and for his wife, Eileen.

☞ Q 12.

What famous autobiographer is supposed to have collaborated with Lorenzo da Ponte in writing parts of the libretto of Mozart's *Don Giovanni,* had forty-two of his own works published during his lifetime, received the Order of the Golden Spur from the pope, introduced the national lottery to France, and translated Homer's *Iliad* into Italian, yet when he died at the age of seventy-three was not at all well known?

QUESTIONS

☞ **Q 13.**

Why did Dante title his most famous work *Divina Commedia* (*The Divine Comedy*)?

☞ **Q 14.**

When was the first free public library opened in France?

☞ **Q 15.**

Why did Mary Ann Evans (1819–1880) change her name to George Eliot when she became a novelist in the mid-nineteenth century?

☞ **Q 16.**

When *Life with Father* opened on Broadway in 1939, what New York daily had this to say about the record-breaking play: "There is not a moment of honest joy or passion in its daguerreotype tableau"?

☞ **Q 17.**

On March 11, 1888, balmy weather in New York, reaching close to 70 degrees Fahrenheit, inspired Walt Whitman (1819–1892) to write a poem about the first daffodils of spring. Why did he feel relieved the next day that he had quickly gotten this poem down on paper?

☞ **Q 18.**

In 1887 Empress Elisabeth of Austria urged the German city of Düsseldorf to erect a memorial to honor the

famous poet Heinrich Heine (1797–1856), who had been born there. She provided some money, and Düsseldorf started to raise funds for a marble statue that was to be designed by the Berlin sculptor Ernst Herter. Eventually, anti-Semitic opposition from Vienna and Berlin brought an end to the undertaking, but the statue was completed and acquired by another city far from Düsseldorf. Where does it stand today?

☞ **Q 19.**

On June 18, 1858, Charles Darwin (1809–1882) received an article from the naturalist Alfred Russel Wallace (1823–1913), who was then ill in Ternate in the Molucca Islands. The article summarized Wallace's theory of evolution by natural selection. How can it be proven that Darwin did not plagiarize some of Wallace's theories in his own *On the Origin of Species,* which was not published until November 24, 1859?

☞ **Q 20.**

Who said: "Whenever I hear the word culture, I reach for my revolver"?

☞ **Q 21.**

What famous English novelist is buried in two different places? Hint: He was intimately associated with Max Gate.

☞ **Q 22.**

Her poetry is read by millions of people in the United States, in all walks of life—more frequently than the

poetry of most other living poets. Although Susan Polis Schutz (b. 1944) has written more than a dozen books of poetry that have sold in the thousands, her poems have been bought and read by millions. How can you explain this?

☞ **Q 23.**

Who expressed these sentiments in a love letter to his mistress at the turn of the twentieth century: "How happy and proud I will be when the two of us together will have brought our work on the relative motion to a victorious conclusion!"?

☞ **Q 24.**

The birth name of this popular American author, born in 1941, was Howard Allen O'Brien. By what name is the writer best known today?

☞ **Q 25.**

Why do modern historians give greater credence to the messenger's magnificent speech about the sea battle of Salamis (480 B.C.) in Aeschylus' play *The Persians* than to the more objective account of the same battle by the professional historian Herodotus (ca. 484–424 B.C.) in his *History of the Persian Wars*?

☞ **Q 26.**

Where can we find the thousands of books that Thomas Jefferson (1743–1826) owned?

THE LITERARY WORLD

☞ **Q 27.**

In what way was little-known Edward Aswell closely associated with Thomas Wolfe after the author's death in 1938?

☞ **Q 28.**

Historian Samuel Eliot Morison's *The Two-Ocean War* and Walter Lord's *Day of Infamy* credited Rear Admiral Patrick Bellinger with sending the historic message, "Air raid, Pearl Harbor—this is no drill," to Washington early on December 7, 1941, and this was supported by Lieutenant Colonel Eddy Bauer in the 24-volume *Illustrated World War II Encyclopedia.* However, Gordon Prange, in *At Dawn We Slept,* claimed that it was Lieutenant Commander Logan C. Ramsey who first sent the message. Who was right?

☞ **Q 29.**

The Baron Charlus in Marcel Proust's (1871–1922) *Remembrance of Things Past* was based on what real-life person?

☞ **Q 30.**

What famous twentieth-century English author characterized novelist and social reformer Charles Dickens (1812–1870), by writing that he "succeeded in attacking everybody and antagonizing nobody"?

QUESTIONS

☞ **Q 31.**

In the novel *Uncle Tom's Cabin* by Harriet Beecher Stowe (1811–1896), Uncle Tom was a black slave. What city named a subway station in his honor?

☞ **Q 32.**

Can G. K. Chesterton's anti-Semitism be attributed to his ultra-conservative Catholicism?

☞ **Q 33.**

Although it is well known that H. L. Mencken (1880–1956) often aroused great anger because of his verbal attacks on organized religion, particularly Judaism, was he also considered an antiblack racist?

☞ **Q 34.**

"If you have a pistol in the first act, it's got to be fired later in the play." This is a maxim commonly attributed to the great Russian playwright Anton Chekhov (1860–1904). In which of his works does it appear?

☞ **Q 35.**

Works such as Thomas Paine's *Common Sense,* Harriet Beecher Stowe's *Uncle Tom's Cabin,* Karl Marx's *Das Kapital,* and Adolf Hitler's *Mein Kampf* had a profound influence on history. In 1962, which single literary work helped to inspire the landmark antipoverty measures in the United States—Medicare, Medicaid, food-stamp

benefits, expansion of Social Security, and federal aid to education?

☞ **Q 36.**

In 1946 Dr. Benjamin Spock's *The Common Sense Book of Baby and Child Care* was published, making him the most famous pediatrician of the twentieth century. However, twenty-two years earlier his name was also reasonably famous from newspaper accounts around the world. Why?

☞ **Q 37.**

In what famous twentieth-century novel, written in German, were the first and last chapters composed first, with the rest of the novel being written within five months?

☞ **Q 38.**

What great mystery writer lived up to his craft and died in a most mysterious way?

☞ **Q 39.**

How did the author of *All Quiet on the Western Front* arrive at its tragic ending?

☞ **Q 40.**

Over the last two centuries, millions of youngsters everywhere have been enchanted by *Grimm's Fairy*

QUESTIONS

Tales. How many fairy tales did the brothers Grimm actually collect? What else is one of the brothers famous for?

☞ **Q 41.**

Edward Geary Lansdale joined the Office of Strategic Services immediately after the Second World War, becoming an expert in psychological warfare. He dreamed up ingenious ways to sabotage the Vietminh in the 1950s; headed Operation Mongoose, the clandestine campaign against Fidel Castro; and contrived the defeat of the Communist-dominated Hukbalahap rebellion in the Philippines. In what two well-known novels was he the model for the hero?

☞ **Q 42.**

What was the origin of the term "the lost generation," referring to writers—especially American ones—after the First World War?

☞ **Q 43.**

What was unusual about Sherlock Holmes's addiction to cocaine?

☞ **Q 44.**

What else, besides the character of Sherlock Holmes, did Sir Arthur Conan Doyle invent?

☞ **Q 45.**

Of the works of the three great Athenian tragedians of the fifth century B.C., only seven plays apiece survive by Aeschylus (including a trilogy about the family of Agamemnon) and Sophocles (including three separate plays about the family of Oedipus), and nineteen survive by Euripides (including *The Trojan Women, Medea,* and *The Bacchae*). How many more plays did they actually write?

☞ **Q 46.**

How was the novel *Madame Bovary* by Gustave Flaubert (1821–1880) received by the highly respected French newspaper *Le Figaro* in 1857?

☞ **Q 47.**

What world-famous twentieth-century novel was originally titled *The Last Man in Europe*?

☞ **Q 48.**

When Claire Clairmont, one of Percy Bysshe Shelley's (1792–1822) mistresses and the mother of his daughter Allegra, refused to hand over Shelley's love letters to the American novelist Henry James (1843–1916), what was James's reaction?

QUESTIONS

☞ **Q 49.**

About a dozen of the finest lyric poems of the eighteenth century were written by William Blake (they were published by friends in the collection *Poetical Sketches* in 1783). What was so remarkable about this?

☞ **Q 50.**

For what reason did Leo Tolstoy (1828–1910) leave his home for good in October 1910, and where did he intend to go?

☞ **Q 51.**

What great English philosopher's works did Sigmund Freud help translate into German?

☞ **Q 52.**

What French novelist exposed his own anti-Semitic prejudice in a well-known novel three years before the Jewish Captain Alfred Dreyfus (1859–1935) was brought to trial for treason, in a case that convulsed French society and brought a wave of anti-Semitism to France at the end of the nineteenth century?

☞ **Q 53.**

The Norwegian novelist Knut Pedersen (1859–1952), who wrote under the name Knut Hamsun, won the Nobel Prize for literature in 1920, and Isaac Bashevis

THE LITERARY WORLD

Singer (1904–1991) claimed that twentieth-century fiction largely stemmed from his work. Yet no biography of him ever appeared in Norway. Why not?

☞ **Q 54.**

The following individuals have something in common: 1930s movie star Jean Harlow, French actress Sarah Bernhardt, Texas oil billionaire H. L. Hunt, Italian dictator Benito Mussolini, American television reporter Harry Reasoner, British Prime Minister Winston Churchill, Nazi propaganda minister Dr. Joseph Goebbels. What is it?

☞ **Q 55.**

When Leo Tolstoy (1828–1910) first started writing *War and Peace* in installments for a Russian magazine, he had a different title for this famous historical novel. What did he want to call it?

☞ **Q 56.**

Allen W. Dulles (1893–1969), director of the CIA from 1953 to 1961, once wrote a book called *The Boer War: A History.* It was published by Gordon Press and is today in the rare book collection at the Library of Congress in Washington, D.C. What is so "rare" about it?

☞ **Q 57.**

Which god, according to Homer in the *Iliad,* enabled the Trojan prince Hector to kill the Greek warrior Patroclus,

then permitted Patroclus' friend Achilles to slay Hector, and finally guided the fatal arrow shot by Trojan prince Paris into Achilles' vulnerable heel?

☞ **Q 58.**

It is no secret that Sir Maurice Oldfield, the former chief of MI-6 (Military Intelligence, Espionage), Britain's super-secret intelligence service, served as the prototype of novelist John Le Carré's (b. 1931 as D. J. Cornwell) spy master, George Smiley. However, what was the most radical difference between the fictitious and the real-life spy?

☞ **Q 59.**

In 1892, Thomas Bailey Aldrich wrote in the *Atlantic Monthly* that a certain female American poet was "an eccentric, dreamy, half-educated recluse, destined for oblivion." To whom was he referring?

☞ **Q 60.**

Why is Charles Dickens's son Francis buried in Moline, Illinois?

☞ **Q 61.**

What nineteenth-century French author was tutored by Flaubert, and, after initial failures and a period of drug

46

addiction, eventually produced more than thirty books in the last eleven years of his life (he died at the age of forty-two)? Benjamin Britten's (1913–1976) opera *Albert Herring* is based on his *Le Rosier de Madame Husson.*

☞ Q 62.

Can you name the famous real-life people who served as models for characters in Aldous Huxley's (1894–1963) *Point Counter Point* (1928), W. Somerset Maugham's (1874–1965) *Cakes and Ale* (1930), and Joyce Cary's (1888–1957) *The Horse's Mouth* (1944)?

☞ Q 63.

What last major story written by a world-famous American author born in the nineteenth century contained numerous allusions to the author's own life such as, for instance, that the two daughters could not find proper suitors and that the wife speculated in coal?

☞ Q 64.

Today she is not known for any single outstanding book, yet her work is still read. For decades she drank to excess. She attempted suicide on several occasions; remarried her ex-husband Alan Campbell in 1950; spent her declining years in the company of many unhousebroken dogs; and insisted on being cremated in a party dress that Gloria Vanderbilt had given her. Who was this American writer?

☞ Q 65.

Thirty-three members of what famous twentieth-century author's family have made their living as writers since 1816?

☞ Q 66.

In his 1859 novel *The Virginians,* William Makepeace Thackeray (1811–1863) made a passing reference to a certain famous man who had long-jumped 6.78 meters (22 ft 3 in). Who was it?

☞ Q 67.

What eminent person published a blistering attack on smoking as early as 1604?

☞ Q 68.

When Arthur Miller (b. 1915) rented a house at Pyramid Lake near Reno, Nevada, in 1956, in order to fulfill the six-week requirement for a divorce decree, who rented the house next door to him, and for what reason?

☞ Q 69.

In what war did the book *Summary on the Art of War* by Baron Antoine Henri de Jomini (1779–1869), which

THE LITERARY WORLD

dealt with Napoleon's military tactics, become a virtual instruction manual?

☞ **Q 70.**

What literary-minded and deeply religious Catholic youth began his voluminous diaries with these words in 1924: "May this book help me to be clearer in spirit, simpler in thought, greater in love"?

☞ **Q 71.**

What were the two English literary works of genius that appeared in 1922?

☞ **Q 72.**

What is the most widely used short verbal expression in the world, and how did it originate?

☞ **Q 73.**

A famous writer was three years old when he was orphaned. Early in the twentieth century he wrote the following lines: "Yes, yes, my Maman, whom I was never able to call because I did not know how to talk when she died. She is my highest image of love—not cold, divine love, but warm, earthly love, maternal . . . Maman, hold me, baby me!" Who wrote these words, and how old was the author when they were written?

QUESTIONS

☞ **Q 74.**

How did the writings of Aristotle (384–322 B.C.) first become widely known in the West?

☞ **Q 75.**

Does William Shakespeare (1564–1616) ever specifically mention any book of the Old or New Testament in his plays?

☞ **Q 76.**

Which narrative poems did Shakespeare adapt from the work of a Roman poet?

☞ **Q 77.**

When Christian IV of Denmark visited his brother-in-law, James I of England, during the summer of 1606, what play did Shakespeare write to celebrate the occasion?

☞ **Q 78.**

Who wrote the following statement in the journal published by the German Society for Psychotherapy almost immediately after Hitler came to power in 1933: "The factual and well-known difference between Germanic and Jewish psychology should no longer be blurred"? The writer then continued to exalt the "Germanic" and

denigrate the "Jewish" psychology, especially Freud's theories.

☞ Q 79.

Which particular episode of the Trojan War was treated by Chaucer (c. 1340–1400), Shakespeare, and Dryden (1631–1700)?

☞ Q 80.

Between October 1787 and May 1788, eighty-five articles appeared in the New York newspapers, under the anonym "Publius," arguing in favor of ratification of the Constitution of the United States, which had been adopted on September 17, 1787, by the Convention in Philadelphia. The following year they were published in book form under the title *The Federalist*. Who wrote them?

☞ Q 81.

Who was the model for Machiavelli's famous 1515 political treatise *Il Principe* (*The Prince*), in which pragmatic, even opportunistic, political techniques are rationalized?

☞ Q 82.

What was the principal pen name of Frederick Schiller Faust (1892–1944)?

QUESTIONS

☞ Q 83.

Of the American writers buried at Woodlawn Cemetery in the Bronx, New York, one of them has absolutely nothing engraved on his tombstone. Who is this famous American writer?

☞ Q 84.

The following motion pictures have one thing in common. What is it? *The Story of Temple Drake* (1933); *Today We Live* (1933); *The Road to Glory* (1936); *Slave Ship* (1937); *Gunga Din* (1939); *To Have and Have Not* (1944); *The Southerner* (1945); *The Big Sleep* (1946); *Land of the Pharaohs* (1955).

☞ Q 85.

What American publisher was buried with a copy of his own newspaper?

☞ Q 86.

What is the single genre that is well represented in European and American literature but was almost non-existent in Russian literature under communism?

☞ Q 87.

What world-famous writer died of the "flue" at the beginning of the twentieth century?

THE LITERARY WORLD

☞ **Q 88.**

What nineteenth-century German poet married an illiterate shop girl who had no idea how important he was and continued to ask friends incredulously if he was really as famous as they maintained?

☞ **Q 89.**

Who wrote: "Build a better mousetrap, and the world will beat a path to your door"?

☞ **Q 90.**

Who first published instructions on how a computer could be made to work?

☞ **Q 91.**

What famous American writer married his consumptive 13-year-old cousin?

☞ **Q 92.**

Exactly what did the English poet John Donne (1571–1631) mean to celebrate when he wrote the following line about a century after Columbus's 1492 landing in the New World: "O my America! my new-found land"?

☞ **Q 93.**

What is the name of the eighteenth-century metaphysical thesis in which it is argued that everything consists of innumerable units whose individual properties determine their past, present, and future? And in what language was it written by its originator?

☞ **Q 94.**

Can you name a world-famous novel in which these words appear: "Frankly, my dear, I don't give a damn"?

☞ **Q 95.**

What is the top-selling copyrighted book in publishing history?

☞ **Q 96.**

What writer has had more titles published than any other? And what other literary record is this writer known for?

☞ **Q 97.**

What does the American actor, humorist, and drama critic Robert Benchley have in common with Adolf Hitler? And how is he associated with Guy Fawkes, the man accused of trying to blow up England's Houses of Parliament?

THE LITERARY WORLD

☞ **Q 98.**

What seems to be wrong with these two opening lines of one of the most famous American short stories in the last hundred years—O. Henry's (pen name of William Sydney Porter, 1862–1910) "The Gift of the Magi": "One dollar and eighty-seven cents. That was all. And sixty cents of it was in pennies . . ."?

☞ **Q 99.**

Can you find a factual or grammatical error in the following sentence? And what does the "S" stand for?

"Harry S Truman (1884–1972), a Democrat, was the 33rd president of the United States from 1945–1953."

☞ **Q 100.**

Truman Capote (1924–1984) told what person that he modeled his *Breakfast at Tiffany's* (1958) heroine, Holly Golightly, after her? Hint: She was twice married to Pulitzer Prize–winning playwright and author William Saroyan (1908–1981), then married a famous movie star and wrote her memoirs.

☞ **Q 101.**

What book, constantly revised and still in print after about a century and a half, had this subtitle: *Classified and Arranged so as to Facilitate the Expression of Ideas and Assist in Literary Composition*? Hint: The author was an English physician.

MUSIC

☞ **Q 1.**

Can you recite the first line, in English or Spanish, of the Spanish national anthem? Who was the composer, and what does it have in common with the national anthems of Mauritania and the United Arab Emirates?

☞ **Q 2.**

Why was Ludwig van Beethoven's (1770–1827) Piano Concerto No. 5 in E-flat Major called the *Emperor*? And who was the soloist when it was performed in Vienna in 1812?

☞ **Q 3.**

What great twentieth-century composer was commissioned to write some ballet music for young elephants?

QUESTIONS

☞ **Q 4.**

In the 1920s and 1930s, he was considered the finest Mozart tenor of his time, yet when he sang pop music, his voice was criticized as schmaltzy, lacking substance, texture, and beauty. His name was a household word nevertheless. He sang in public for thirty years—including works by Puccini, Wagner, Schubert *lieder,* and, during World War II, English ditties, operettas, and movie musicals. Today he is largely forgotten. Who was this Austrian singer? Did his public appearances in the forties support him well?

☞ **Q 5.**

What well-known conductor made a speech to a packed concert hall prior to a performance of a famous concerto, disassociating himself completely from the soloist's interpretation and performance? Which concerto was it, and who was its soloist?

☞ **Q 6.**

Who wrote the words to the final movement of Beethoven's Ninth Symphony?

☞ **Q 7.**

What do these three songs have in common: Rudolf Friml's "Chansonette" (1923), Duke Ellington's "Never

MUSIC

No Lament" (1940), and Irving Berlin's "Smile and Show Your Dimple" (1917)?

☞ **Q 8.**

There is one live character in Richard Wagner's (1813–1883) tetralogy *Der Ring des Nibelungen* who is on stage with Brünnhilde and even addressed by her, but Wagner did not write a single note of music for this character. Do you know why?

☞ **Q 9.**

Who made the following statement about what? "To some, it is Napoleon. To some, it is struggle. To me, it is *allegro con brio.*"

☞ **Q 10.**

When was the first time that a so-called "psychedelic" light show was coordinated with a live performance of music?

☞ **Q 11.**

In 1828 the first movement of this new symphony was considered so long and complicated that the Viennese orchestra planning its performance refused to finish playing it even at the first rehearsal. So discouraged

QUESTIONS

was its composer that he withdrew the symphony altogether and never heard it played in his lifetime. Another composer later saved it from oblivion. Which composer revived whose symphony in 1839?

☞ **Q 12.**

Only one-third of the world's surface ever enjoys what Bing Crosby (1904–1977) has been crooning about since the early forties. What is it?

☞ **Q 13.**

What do the premieres of Puccini's (1858–1924) operas *La Bohème, Madama Butterfly, The Girl of the Golden West,* and *Turandot* have in common?

☞ **Q 14.**

Name the composers of *The Barber of Seville, La Bohème, The Four Seasons,* and *Don Giovanni.*

☞ **Q 15.**

Does any work in Beethoven's (1770–1827) canon resemble Johann Sebastian Bach's (1685–1750) Goldberg Variations?

☞ **Q 16.**

Why did the Bach biographer and organist Albert Schweitzer (1875–1965) consider Bach's *Christmas Oratorio* misnamed?

MUSIC

☞ Q 17.

What is the connection between Wolfgang Amadeus Mozart's (1756–1791) *Jupiter* Symphony and the training of pianists?

☞ Q 18.

When Lauren Bacall (b. 1924) sang in her 1944 motion picture debut *To Have and Have Not,* did you hear her own voice on the soundtrack or somebody else's?

☞ Q 19.

One of the most famous of all rock singers forsook his native South London as well as the United States for a house near the former Berlin Wall. He was born David Robert Jones. What name is he known by today?

☞ Q 20.

Why did Richard Wagner (1813–1883) decide to build his own opera house (in Bayreuth)?

☞ Q 21.

She called herself "the Queen" and made a name for herself in blues, jazz, popular songs, and rhythm and blues. She frequently sang with Lionel Hampton's band, went through more than half a dozen marriages, then died in her thirties in the 1960s from an overdose of pills and alcohol. Although she was world famous, she is not even mentioned in the *Encyclopaedia Britannica.* Who was the lady?

QUESTIONS

☞ **Q 22.**

Irving Berlin (1888–1989) wrote one theme song that could be heard in every production of a musical series produced during the twenties and thirties. What was the theme song and for which musical series did he write it?

☞ **Q 23.**

What is the piece of music that concludes every Pablo Casals (1876–1973) Festival?

☞ **Q 24.**

Probably the most prolific French composer of the last seventy-five years, he was afraid he would be remembered only for a composition that lasts about as long as the average movement of a symphony. Who was the composer and what is this popular piece?

☞ **Q 25.**

What was the last work Richard Wagner conducted? Where did he conduct it?

☞ **Q 26.**

What tragedy was the inspiration for Johannes Brahms's (1833–1897) *Tragic Overture*?

MUSIC

☞ **Q 27.**

The Swiss composer Arthur Honegger (1892–1955) first set his biblical oratorio *King David* to music in 1921. More than sixty years later it was discovered that a unique item in his studio may have inspired him to write it. What was that object?

☞ **Q 28.**

How could Irving Berlin (1888–1989) compose music on a piano when he could read only music in the key of F sharp?

☞ **Q 29.**

Which composer had the most concertos to his credit? Who composed the most string quintets? What person, not so much known for his musical talents, wrote the greatest number of flute concertos? How many did each of them write?

☞ **Q 30.**

Who was the first popular song lyricist to be awarded the Pulitzer Prize? His first song lyric, published in *The Evening Sun* in 1917, was called, "You May Throw All the Rice You Desire (But Please, Friends, Throw No Shoes.)" (Hint: He was the godfather of Liza Minnelli.)

QUESTIONS

☞ **Q 31.**

Of the world's famous composers and musicians, who lived the longest?

☞ **Q 32.**

What world-famous popular-music soloist was also admired by classical composers? In fact, Paul Hindemith (1895–1963) and Béla Bartók (1881–1945) actually composed music for him, and he also worked closely with Aaron Copland (1900–1990) and Igor Stravinsky (1882–1971).

☞ **Q 33.**

The Vienna Philharmonic was founded in March 1842. Before the end of the nineteenth century, it had three permanent principal conductors and music directors: Dessoff, Richter, and Mahler. Guest conductors included Strauss, Wagner, Bruckner, Toscanini, Bernstein, Walter, Solti, Hindemith, Furtwängler, and many others. How many permanent conductors and music directors has the Vienna Philharmonic had since Mahler left in 1901?

☞ **Q 34.**

What do the composers Johann Sebastian Bach (1685–1750), George Frederick Handel (1685–1759), Bedřich Smetana (1824–1884), and Frederick Delius (1862–1934) have in common?

MUSIC

☞ **Q 35.**

Ludwig van Beethoven (1770–1827) was one of the world's greatest composers. Do you know the last name of another Ludwig (von) who is closely associated with the music of another of the world's greatest composers?

☞ **Q 36.**

What composer born in Dresden wrote thirty-two symphonies?

☞ **Q 37.**

Well before Mozart (1756–1791) was buried in an unknown pauper's grave, another great composer had also died impoverished. At the end of his life, he could no longer compose, although he did perform for the king. After he died, his family lost most of his compositions. What was the name of this composer? And who was the equally great composer who twice refused to meet him?

☞ **Q 38.**

What is the approximate number of years that elapse—from beginning to end—in the story line of Wagner's *Der Ring des Nibelungen*? (From *Das Rheingold* through *Götterdämmerung*?)

QUESTIONS

☞ **Q 39.**

What title did Piotr Ilich Tchaikovsky (1840–1893) confer upon his Sixth Symphony?

☞ **Q 40.**

Six beautiful concertos, known as the *concerti armonici,* were composed in the eighteenth century. Who wrote them?

☞ **Q 41.**

In the eighteenth century, a composer wrote a concerto for the trumpeter Anton Weidinger. Eight years later, another composer was so taken by Weidinger's talents that he also wrote a concerto for him. Who were the two composers? (Hint: Both composers' last names start with the same letter of the alphabet.)

☞ **Q 42.**

Which country has the oldest military band tradition in the world?

☞ **Q 43.**

How did Mozart react to the tumultuous success of his Symphony No. 31 (K. 297), the *Paris*?

☞ **Q 44.**

In which opera can the following words be heard? "Damn the United States! I never want to hear of them

again." A hint: The composer also conducted the opera's 1936 premiere at the Metropolitan Opera House in New York. It has not been performed there since.

☞ **Q 45.**

Who wrote the overture to the romantic drama *Rosamunde*?

☞ **Q 46.**

Some people consider this composer's finest achievement an opera that was left incomplete when he died a few years after World War I. Who was the composer and what was the opera?

☞ **Q 47.**

What do the classical composers Delius, Borodin, Wagner, Shostakovich, Schumann, Lortzing, Busoni, and Berg have in common?

☞ **Q 48.**

What did Beethoven intend the four-note musical phrase that begins his Fifth Symphony to represent?

☞ **Q 49.**

What do the following compositions have in common: Brahms, *Triumphlied;* Dvořák, the cantata *The American Flag;* Weber, the cantata *Kampf und Sieg;* Handel, *Occasional Oratorio;* J. C. Bach, Keyboard Concerto in D, op. 1, no. 6; Beethoven, *Battle of Vittoria* Symphony; Ives,

QUESTIONS

Lincoln, the Great Commoner; Weber, *Jubel* Overture; Paganini, Variations for Violin and Orchestra, op. 9?

☞ **Q 50.**

What two world-famous East European composers were born in the same country but are *each* buried in *two* different places?

☞ **Q 51.**

Over the past two centuries, one melody has been the anthem of Vienna (1782), Prussia (1795), Switzerland (1811), Bavaria, Mecklenburg, Schwerin, and Liechtenstein. Even Sweden and Eire have at one time taken the tune as an unofficial national anthem. Which country still uses it as its national anthem?

☞ **Q 52.**

In 1931, a famous jazz artist recorded "Dallas Blues" and sang the following lyric: "Gonna put myself on the Santa Fe and go, go, go . . ." Twelve years later the same singer took the Santa Fe *Chief* and died aboard the train at the age of thirty-nine. He had pneumonia. Who was he?

☞ **Q 53.**

What famous composer was fatally shot in Austria by an American sentry on September 15, 1945, just a few

days after the end of World War II, because he did not understand the sentry's English warning? What happened to the sentry?

☞ **Q 54.**

When the *Titanic* went down in 1912, after striking an iceberg, what exactly did the five-man band on the deck of the sinking ship play?

☞ **Q 55.**

Who modernized Handel's *Messiah* after the composer's death, and what new instrument did the arranger of the modern version introduce into the score?

☞ **Q 56.**

What wealthy and successful insurance executive, born in 1874, feverishly pursued a hobby that brought him little fame in his own lifetime, yet later won him international acknowledgment as a pioneer of American music?

☞ **Q 57.**

When the Suez Canal was opened in 1869, what masterpiece was commissioned and performed to celebrate the occasion?

QUESTIONS

☞ **Q 58.**

What famous nineteenth-century composer wrote that Johannes Brahms (1833–1897) was a "scoundrel" and a "bastard," and referred to his compositions as "dried stuff"—especially his piano concertos?

☞ **Q 59.**

In which two very well-known, serious operas doesn't a single death occur?

☞ **Q 60.**

In which twentieth-century symphony can two (formerly three) hammer blows be heard in the final movement? And why was the third hammer blow later removed?

☞ **Q 61.**

What important thing did Franz Liszt's daughter and Richard Wagner's three children have in common?

☞ **Q 62.**

In the stage version of Harvey Fierstein's (b. 1954) *Torch Song Trilogy,* the actor portraying his adopted son dedicates a song to him on the radio in the last of the three one-act plays. What is the song and who sings it?

MUSIC

☞ Q 63.

Why did Pope Pius X ban one of the first phonograph recordings in Italy, Alessandro Moresci's rendition of the Bach-Gounod *Ave Maria* and sixteen other songs?

☞ Q 64.

What composer had an affair with Coco Chanel (1883–1971) and then lived with a mistress much taller than he while still married to his tubercular cousin? (Hint: He was well known for his avarice, and even though he professed admiration for fascism, his music was banned in Mussolini's Italy and Hitler's Germany.)

☞ Q 65.

Was the first American Broadway musical comedy performed before or after World War I, and what is known about it?

☞ Q 66.

When was the first French musical produced? Who were its creators and what was its title?

☞ Q 67.

What two world famous singers died exactly one month apart in 1977?

QUESTIONS

☞ **Q 68.**

Whose songs were used in the motion picture *An Officer and a Gentleman*?

☞ **Q 69.**

Which song was banned by the BBC in Great Britain, even though it had been among the top ten for over a month, including one week as the number one favorite of the country?

☞ **Q 70.**

The prestigious English journal *London's Musical World* wrote in 1841 that the entire works of which composer produced "an excruciating cacophony"?

☞ **Q 71.**

What famous composer's only symphony, composed when he was just sixteen, was turned down by all music publishers, was then misplaced and not rediscovered until sixty years after the composer's death? (It received its world premiere in 1935 under the baton of Felix von Weingartner [1863–1942]).

☞ **Q 72.**

At the premiere of Richard Wagner's only symphony, the pianist was a thirteen-year-old girl. What orchestra

performed the symphony, and who was the female soloist?

☞ **Q 73.**

What major twentieth-century composer said to his daughter-in-law just before he died, "Dying is just as I composed it"?

☞ **Q 74.**

Richard Wagner once said, "This Strauss is an odious fellow, but when he plays the horn, it is impossible to be angry with him." Which Strauss was Wagner referring to?

☞ **Q 75.**

Under what title was the song "St. Louis Blues" known by the Austrian Nazis?

☞ **Q 76.**

Where and when was the first magazine devoted entirely to jazz published? Where and when was the first jazz club established?

☞ **Q 77.**

Walking through a park on a wintry night, a married woman confesses to her lover that she is bearing the child of the husband she does not love. The lover's

QUESTIONS

trust in the woman transcends all jealousy, and he knows he will love her forever. This is the gist of a poem that inspired a twentieth-century composer to write a string sextet in 1899, which he later revised and transcribed into an orchestral piece. Who were the poet and the composer?

☞ **Q 78.**

Until the first half of the twentieth century, the *Toy Symphony* was mistakenly attributed to which composer? Who was its real composer?

☞ **Q 79.**

What was unusual about Wilhelm Furtwängler's 1953 recording of Wagner's *Tristan und Isolde,* in which Kirsten Flagstad (1895–1962) sang the role of Isolde?

☞ **Q 80.**

What famous score was Piotr Ilich Tchaikovsky (1840–1893) working on when he came to New York to conduct the opening concert at Carnegie Hall (May 5, 1891)?

☞ **Q 81.**

In what year did Paul Hindemith (1895–1963) write his first score for a motion picture?

☞ **Q 82.**

In the first half of the nineteenth century the concertmaster of the Leipzig Gewandhaus Orchestra, Fer-

dinand David, performed the world premiere of a violin concerto on the same instrument that the great violinist Jascha Heifetz (1901–1987) was later to use exclusively for many decades. What was this concerto?

☞ **Q 83.**

What composer, when composing his piano concertos, wrote out the piano part first and then, on separate sheets of paper, wrote down the orchestra part? Why did he do this?

☞ **Q 84.**

Why did Cole Porter (1892–1964) change a line of his song "I Get a Kick out of You" between the time he composed it in 1931 and the original 1934 production of *Anything Goes,* in which Ethel Merman introduced it?

☞ **Q 85.**

Who wrote the frothy, one-act comic opera *Le devin du village*?

☞ **Q 86.**

Hardly any of Johann Sebastian Bach's works had been performed in almost eighty years following his death in 1750 (they were considered stodgy and old-fashioned), and none of his choral works had been in print for several decades when, in 1829, one person undertook the project of bringing back Bach's music. Who did this? What other great but neglected music did he reintroduce to the public?

QUESTIONS

☞ Q 87.

Edward Kennedy is not only the name of a twentieth-century United States senator, but also the first two names of a famous twentieth-century composer. What is the composer's last name?

☞ Q 88.

What do the following four operas have in common? Who wrote them? *La maledizione di Saint-Vallier* (1850), *Viscardiello* (1851), *Clara di Perth* (1853), and *Lionello* (1858).

☞ Q 89.

When Frédéric Chopin (1810–1849) wrote his 1830 Piano Concerto No. 1 in E Minor he based it partly on an earlier piano concerto by whom?

☞ Q 90.

What are the three most often sung songs in the English language?

☞ Q 91.

Whose piano did George Gershwin (1898–1937) play at the last party he ever attended, a week before he died?

☞ Q 92.

Who was the youngest pop star ever to have written, arranged, produced, and performed a number one song?

MUSIC

☞ **Q 93.**

What was the great contribution to music by Guido of Arezzo of the twelfth century and the Frenchman Philippe de Vitry of the fourteenth?

☞ **Q 94.**

What was unique about Benvenuto Busoni's (1866–1924) only piano concerto?

☞ **Q 95.**

What is the name of the only song Jerome Kern (1885–1945) published that he did not write either for a stage musical or a motion picture?

☞ **Q 96.**

Who coined the phrase, "I like Ike"?

☞ **Q 97.**

Why does the musician Ray Charles (b. 1930) almost always stay at Holiday Inns when traveling?

☞ **Q 98.**

What was the only Gershwin song ever to reach the top of "The Hit Parade"?

QUESTIONS

☞ **Q 99.**

For what achievement did actor Keith Carradine (b. 1950) win an Oscar?

☞ **Q 100.**

Who persuaded Leonard Bernstein (1918–1990) to become a conductor?

☞ **Q 101.**

John Bull, especially as represented in cartoons, is used as a personification of England. The name was popularized by Dr. Arbuthnot's *History of John Bull* (1712). Is there another John Bull who will always be associated with what is singularly British?

☞ **Q 102.**

What opera did the great Italian tenor Enrico Caruso (1873–1921) regard as his good-luck piece, even though it would later become an omen of his early death?

☞ **Q 103.**

The Italian composer Gioacchino Rossini lived from 1792 to 1868. At what age did he stop composing operas?

☞ **Q 104.**

Two of the operas Rossini composed were *The Siege of Corinth* and *William Tell,* and two of the operas Verdi

MUSIC

composed were *I vespri siciliani* and *Don Carlos*. Which of these operas was originally written in French?

☞ **Q 105.**

One of the world's leading conductors since the 1970s has been Christoph von Dohnanyi (b. 1929). What is the link between him and Dietrich Bonhoeffer (1906–1945), the German evangelical theologian, who was executed by Hitler's SS?

☞ **Q 106.**

What performer is the wealthiest musician of all time, has penned thirty-two number one musical hits, and has racked up seventy-five gold and platinum disks (more than any other concert artist)? Which one of his songs has had the most recordings, with over two thousand versions?

☞ **Q 107.**

Why is it a misnomer when more than forty recordings and thousands of musical programs always refer to Richard Strauss's (1864–1949) popular *Four Last Songs* as being the four last songs he composed before he died?

☞ **Q 108.**

Name the tone poem by Richard Strauss in which the specific events portrayed have never been determined—not in program notes, articles, nor books dealing with Strauss's work.

QUESTIONS

☞ **Q 109.**

What was ironical about the last recording Glenn Gould (1932–1982) made just before he died?

☞ **Q 110.**

How did the French public drastically affect the operas *Tannhäuser*, by the preeminent German composer of opera, Richard Wagner (1813–1883), and *Don Carlos*, by the preeminent Italian composer of opera, Giuseppe Verdi (1813–1901)?

☞ **Q 111.**

Although he was the most famous anti-Semite of the nineteenth century, Richard Wagner (1813–1883) adopted for one of his operas some of the features of a poem by a man who happened to be the most famous German Jewish writer of the last century. Who was this Jew, and for which opera did Wagner use part of this poem?

FINE ARTS

☞ Q 1.

The name of what small town has come to symbolize a radical break with tradition in both the history of the papacy and the history of painting?

☞ Q 2.

Which of the paintings by Leonardo da Vinci (1452–1519) displays the most horrifying, grotesque figures?

☞ Q 3.

Who was the only painter ever named in a Shakespeare (1564–1616) play?

QUESTIONS

☞ **Q 4.**

What nineteenth-century artist, today considered one of the greatest painters of all time, died at the age of thirty-seven, virtually unknown, having sold only one painting in his lifetime? At one time he was a language teacher in England; he also did some missionary work among the mining population of the Borinage.

☞ **Q 5.**

Pope Leo X (Giovanni de' Medici [1475–1521], the son of Lorenzo the Magnificent) was one of the greatest patrons of the arts in the Italian Renaissance. What was his opinion of Leonardo da Vinci and Michelangelo?

☞ **Q 6.**

On whose gravestone is inscribed his lifelong principle, "Less Is More"?

☞ **Q 7.**

Forty-seven years after he left his native land, the Chinese-American architect I. M. Pei (b. 1917) was commissioned by the government of the People's Republic of China to design the Fragrant Hill Hotel in Beijing. So pleased with the result were the authorities that they asked him in the mid-1980s to build a skyscraper in the same city. Why did he refuse?

FINE ARTS

☞ **Q 8.**

Zeuxis was a famous Ionian Greek painter of the fifth century B.C. For what was he famous?

☞ **Q 9.**

What two eighteenth-century English artists have often been called "the forerunners of French Impressionism"?

☞ **Q 10.**

In the world of art, what significance do Atuona and Hiva Oa have?

☞ **Q 11.**

Which nineteenth-century artist lived in Lima, Peru, until he was seven years old, married a Danish piano teacher named Mette Sophie Gad with whom he had five children, and worked for years as a broker's clerk in Paris?

☞ **Q 12.**

The noted German architect and artist Karl Friedrich Schinkel (1781–1841), who was responsible for designing many of Berlin's finest buildings in the first half of the nineteenth century, was also the designer of what well-known decoration?

QUESTIONS

☞ **Q 13.**

This man commissioned a different artist every year to do a particular job for him. Among the artists commissioned after the Second World War were Jean Cocteau, Georges Braque, Salvador Dali, Henry Moore, Andy Warhol, Marc Chagall, Robert Motherwell, even film director John Huston. Who was he and what did he commission these artists to do?

☞ **Q 14.**

What American artist enjoyed his first popularity in Japan, suffered the greatest tragedy of his life when the woman he lived with was murdered along with her seven children by a demented servant, and had a workshop in Arizona that bore a Finnish name?

☞ **Q 15.**

What American artist named his eleven children after famous painters?

☞ **Q 16.**

What artist was so overwhelmed by the deaths of his mother and little sister when he was a boy in Christiania (now Oslo) that he always portrayed women as a demonic embodiment of the life force? (He had one of his fingers shot off in an accident, suffered

FINE ARTS

an emotional collapse, and he went into seclusion on his estate for over thirty years.)

☞ Q 17.

Of which nineteenth-century French artist has it been said that he painted seven hundred pictures, of which eight thousand are in the United States?

☞ Q 18.

When the thirteenth-century frescoes in St. Mary's Church in the German port of Lübeck were restored in 1951, what extraordinary figures could be found? How did they get there?

☞ Q 19.

Why didn't the following six artists mind being frequently derided for painting trash: Robert Henri, Maurice Prendergast, William Glackens, Jack Smith, Edward Middleditch, and John Bratby?

☞ Q 20.

What artist did Donato Bramante (1444–1514), the architect of several papal palaces in the early sixteenth century, introduce to Pope Julius II and designate as his successor in the building of St. Peter's Basilica? How

QUESTIONS

did the pope feel about the artist's craft after he saw samples of his work?

☞ **Q 21.**

What kind of carved emblems did the Pompeiians place at the corners of buildings in order to advertise masons, smiths, gambling houses, and brothels?

☞ **Q 22.**

What sixteenth-century artist detested "making resemblances of life" in portraiture and when told that the statues on the Medici tombs were not accurate portraits replied, "In a thousand years no one will know the difference"?

☞ **Q 23.**

Where and when did Pablo Picasso (1881–1973) have his first exhibition in the United States?

☞ **Q 24.**

Which famous 1717 painting by a French artist is still the subject of controversy?

☞ **Q 25.**

Who painted a pastel portrait of Vincent van Gogh in 1887 and then persuaded him to leave Paris for Provence?

FINE ARTS

☞ **Q 26.**

What reputation is held by Tintoretto's (1518–1594) painting *Il Paradiso,* which hangs in the Doge's Palace in Venice?

☞ **Q 27.**

What painting, now in the National Gallery of Canada in Ottawa, has been called the first picture depicting a historical event that distorted historical reality to create an effect?

☞ **Q 28.**

Who boasted that he had found a city of brick and left a city of marble?

☞ **Q 29.**

What famous Roman building, erected about twenty years before the birth of Christ, is used as a Christian church today?

☞ **Q 30.**

One of the French Impressionists created mysterious dramas on canvas by painting banal events in unexpected ways and was known for cropping scenes, using strange angles of vision, and incorporating into his painted subjects physiognomic characteristics that were indicative of less refined people. Some aspects of

his work inspired Henri Matisse (1869–1954) and Pierre Bonnard (1867–1947). Who was he?

☞ **Q 31.**

What building inspired the architect of the Virginia State Capitol in Richmond?

☞ **Q 32.**

What is the function of the young soldier, the nude woman, and the flash of lightning that Giorgione (1478–1510) painted into his landscape *The Tempest* (1504)?

☞ **Q 33.**

Why do modern scholars reject the date Titian (Tiziano Vecellio) claimed as his birth date—1477?

☞ **Q 34.**

What was the first building named after Albert Einstein (1879–1955)?

☞ **Q 35.**

Why was the work of the Hungarian photographer André Kertész (1894–1985), acknowledged as a master in Europe, Japan, and Australia as far back as the 1920s,

FINE ARTS

rejected in the United States for decades after his arrival there?

☞ **Q 36.**

Who was considered the greatest sculptor in Tuscany during the first half of the seventeenth century?

☞ **Q 37.**

Who actually completed a painting that was begun by Gentile Bellini (1429–1507) in March 1504 for the Scuola di San Marco in Venice? It was to this artist that Bellini's entire payment was bequeathed.

☞ **Q 38.**

In 1565, Pieter Brueghel (1520–1569) painted a controversial series of pictures, of which only five are preserved. Why is there a controversy between scholars about this series, with some believing there were six paintings in the series while others are convinced that there were twelve?

☞ **Q 39.**

What famous artist was sentenced to twenty-four days in jail in 1912 because his paintings were "pornographic" (two of them were actually burned), was drafted into the army during the First World War, and

QUESTIONS

died at the age of twenty-eight, a few days before the Armistice?

☞ **Q 40.**

In a Buddhist religious festival that takes place every January, fifteen sculptures called Chupas, or offerings to Buddha, are placed around the principal Buddhist temple of Tibet, near Lhasa. In this ancient Tibetan art tradition, what exactly are these sculptures made of?

☞ **Q 41.**

What famous French painter was accused of demolishing the Vendôme column, a symbol of the French Empire, during the uprising of the Paris Commune in 1871, and was fined 300 million francs for its reconstruction?

☞ **Q 42.**

In 1932, the Mexican painter Diego Rivera (1886–1957) was commissioned to create a mural for the new Rockefeller Center in New York to be entitled *Man at the Crossroads*. Originally, however, two other eminent painters had been invited to compete with Rivera for the commission. Who were they?

☞ **Q 43.**

How did Diego Rivera manage to sneak a portrait of Lenin into the mural *Man at the Crossroads,* commis-

FINE ARTS

sioned in 1932 by the Rockefellers, for New York's new Rockefeller Center?

☞ **Q 44.**

What supreme achievement of European art, completed in 1642, has actually been cut down on all sides, especially at its left edge where two figures have been entirely lost? Hint: The painting is better known by its erroneous name than by the title the artist gave it because of the grime and smoke that darkened its originally brilliant noontime setting.

☞ **Q 45.**

One artist brother was nicknamed "Hell" because of his choice of subjects, including charnel scenes, tortures, and mass suffering, while his brother was nicknamed "Velvet" because he excelled in flower-painting and decorative landscapes with exquisitely painted birds and animals. Who were these two painters?

☞ **Q 46.**

What is the world's most frequently visited museum?

☞ **Q 47.**

What painter gloried in the publicity of commissions from such nationally known companies as Dole Pineapple and Elizabeth Arden? The artist even did a

QUESTIONS

mural for the powder room of New York's Radio City Music Hall.

☞ Q 48.

Who created the first important figure of a black man in American painting?

☞ Q 49.

The Flemish painter Brueghel the Elder illustrated a sports activity in one of his winter scenes, in approximately 1560, or half a century after this sport could trace its formal heritage to a club formed near Glasgow. Prior to the 1992 Olympic Games in Albertville, France, the sport was played in only four previous Winter Olympics. What is this sport, and what is its name in competition?

☞ Q 50.

In a letter to his brother, Theo, in 1890, Vincent van Gogh wrote, "I still love art and life very much indeed." Close to the same time, his sister-in-law described him as a "sturdy, broad-shouldered man with a healthy color, a smile on his face, and a resolute appearance." How was his state of mind a few weeks later?

☞ Q 51.

In 1886, when the French poet and art critic Félix Fénéon first saw what was to become one of the most celebrated paintings of the nineteenth century, he coined a name for the new art movement that its young painter represented. What was the name of the art

FINE ARTS

movement (and its alternative name), as well as the title of the 1886 masterpiece by its 27-year-old painter?

☞ **Q 52.**

What is the only marble statue that has eyelashes?

☞ **Q 53.**

Which Renaissance artist influenced Michelangelo (1475–1564), was highly praised by Leonardo da Vinci (1452–1519) and Raphael (1483–1520), and was known for two great innovations that led to the modern era of painting?

☞ **Q 54.**

What world-famous cathedral did not have a dome for the first 150 years of its existence, although the cupola, when finally built, was larger in diameter than the dome of St. Peter's in Rome?

☞ **Q 55.**

What two things are unique about the artist who was instructed by the 79-year-old Michelangelo (1475–1564) when he was 22, and, 70 years later, at the age of 92, taught painting to the 25-year-old Flemish artist Anthony Van Dyck (1599–1641)?

☞ **Q 56.**

What famous artist made the following statement about what particular painting: "I should be happy to give ten

years of my life if I could go on sitting here in front of this painting for a fortnight, with only a crust of dry bread for food"?

☞ Q 57.

What artist's work was so frequently copied that he was largely responsible for the enactment of the first Copyright Act, which protected an artist's original work from plagiarism?

☞ Q 58.

One of the most famous oil paintings in over half a millennium shows the artist's signature smack in the middle of the artwork. Who was the artist and what is the title of the painting? What do the fruits, a dog, and a burning candle symbolize in this painting?

☞ Q 59.

In 1986 James Beck, chairman of art history at Columbia University in New York, referred to an artwork as if its soul had been stripped away, saying that it looked like an "artistic Chernobyl," and noted artists like Robert Motherwell (1915–1991), Andy Warhol (1928–1987), and Robert Rauschenberg (b. 1925) agreed with him. What were these people referring to?

☞ Q 60.

What great painter of the nineteenth century worked only in the studio, from imagination or memory, scorn-

ing the idea of painting in the open air or even from sketches done outdoors? And why did this painter begin to turn to sculpture at the sixth exhibition of the Indépendants in 1881, as well as change, in the same decade, from oil painting to pastel, pencil, gouache, and distemper?

☞ **Q 61.**

Who was the architect of St. Peter's in the Vatican, Rome, as we know the cathedral today?

☞ **Q 62.**

When can you speak of the size of a painting, yet not refer to its height or width?

☞ **Q 63.**

What famous painter born in the nineteenth century named himself after the small town in which he was born?

STAGE AND SCREEN

☞ A 1.

Not at one of the invasion points in France, but at Camp MacKall, North Carolina, where he was preparing explosive charges with nitro-starch packages and blasting caps. Sergeant Russell served with the 513th Airborne Division.

Mr. Russell is the only living Academy Award winner who was forced to sell his Oscar. The 78-year-old Russell auctioned it off in August 1992 to help pay bills for his wife's cataract operation. An anonymous buyer acquired the Oscar in New York City for $60,500, of which Mr. Russell netted $55,000 after the commission took its share. John Lennon's 1971 Oscar for best musical score for the movie *Let It Be* (1970) was auctioned *posthumously* in October 1992 for $110,000.

☞ A 2.

Mia Farrow (b. 1945). Seven of her children are adopted. Her own four children are all boys: three by conductor-composer André Previn (b. 1929), the fourth by actor-writer-director Woody Allen (b. 1935).

ANSWERS

☞ **A 3.**

Chaplin was not Jewish, nor was anyone in his family. Only the father of Charlie's half-brother, Sidney, was Jewish. All the Chaplins were members of the Church of England. Nazi propaganda proved to be so persuasive, however, that even the Jewish Nobel Peace Prize winner of 1935, Carl von Ossietzky (1889–1938), equated Chaplin with Judaism—a mistake that Chaplin never bothered to correct.

☞ **A 4.**

This movie star became a brigadier general in the U.S. Air Force and made many bomber runs over Nazi Germany, including one of the first against the city of Kiel. His name is James Stewart (b. 1908).

☞ **A 5.**

Because without her there would have been no Hollywood. Daeida Wilcox was the wife of Horace Harvey Wilcox, a Kansas real estate developer who bought some land outside Los Angeles, which his wife named Hollywood in 1887. She got the name from the summer residence of a friend in Chicago. In 1903, the community was incorporated as the city of Hollywood, and in 1910 it became a district of Los Angeles.

☞ **A 6.**

In one scene of *The Sound of Music* (1965) Julie Andrews (b. 1935) is seen selecting some apples at a street mar-

ket. An orange box can be seen in the foreground that is clearly marked "Produce of Israel."

☞ A 7.

Charles Laughton (1899–1962). A few years earlier, he had shot many scenes in the title role of a movie based on Robert Graves's *I, Claudius,* but the project was later abandoned.

☞ A 8.

Greer Garson (b. 1908) as Mrs. Miniver in the movie of the same name.

☞ A 9.

Vivien Leigh (1913–1967), who was filming *Ship of Fools* at the time. It happened in the house on Thrasher Avenue that movie director George Cukor had rented for her. She saw Gielgud flailing about in the water and thought at first that he was clowning. When he cried out for help she dove in, pulled him up to the surface, and swam to the edge of the pool where she gave him mouth-to-mouth resuscitation. About an hour earlier, Katharine Hepburn (b. 1909) had taken Leigh to a doctor for shock treatment to combat her depression.

☞ A 10.

Olivier said at the film's premiere that, in contrast with his color-rich *Henry V,* which was like a painting, he considered *Hamlet* to be closer to an etching. Not until the

ANSWERS

1980s did he publicly admit that the painting-etching comparison was pure rubbish. He would gladly have filmed *Hamlet* in color, but at the time of the film's shooting he was involved in a bitter row with the Technicolor Corporation, and he had not been granted the right to do so.

☞ **A 11.**

When Judy Garland (1922–1969) sang the famous trolley song in *Meet Me in Saint Louis,* directed by her future husband Vincente Minnelli (1910–1986), somebody called out, "Hi ya, Judy!" The star seemed to be the only one who noticed it. For a fraction of a second she seemed startled, but she soon recovered and gamely continued with the song as if nothing had happened.

☞ **A 12.**

Abraham Lincoln. But Lincoln (1809–1865) did not become president until 1861; James Knox Polk (1795–1849) was president in 1847. Evidently the Nazis did not check their facts before they made the motion picture *Der Kaiser von Kalifornien* in 1936.

☞ **A 13.**

As Scarlett (Vivien Leigh) leaves the hospital in Atlanta, she hurries past a lamppost lit by electricity.

☞ **A 14.**

It was supposed to be a pun. (No "el.")

STAGE AND SCREEN

☞ **A 15.**

Vincente Minnelli (1910–1986), Liza's father and the husband of Judy Garland. He worked as a director for MGM for twenty-six years and directed, among other movies, *Gigi, An American in Paris,* and *Lust for Life.*

☞ **A 16.**

Chaplin's understudy and roommate in 1914 was Arthur S. Jefferson (1890–1965), better known as Stan Laurel of Laurel and Hardy.

☞ **A 17.**

Supposedly on W. C. Fields's (1879–1946). But it doesn't. The joke first appeared in the magazine *Vanity Fair* in the 1920s, long before it was associated with Fields.

☞ **A 18.**

Judy Garland (1922–1969). Some of the recordings that she made for that movie have been preserved.

☞ **A 19.**

The first costar was Clark Gable (1901–1960), during the filming of *Gone With The Wind.* She used a third party to inform him about it. The second time she complained about Lee Marvin (1924–1987) when filming *Ship of Fools.* She had him banned from the set until he arrived without the smell of liquor on his breath.

ANSWERS

☞ **A 20.**

It was called *The Possibility of War in the Air,* and it was found in the German film archives long after World War II, even though it had been shot in England in 1906—only three years after the Wright brothers' first flight.

☞ **A 21.**

Muni Weisenfreund changed his name to Paul Muni (1895–1967). In 1936, he won an Academy Award for the title role in the movie *The Story of Louis Pasteur.* In 1956, he was awarded the Antoinette Perry ("Tony") award for his performance on the Broadway stage as Clarence Darrow in *Inherit the Wind.*

☞ **A 22.**

Jerry Herman (b. 1933). (*Hello, Dolly!*: 2,844 performances; *Mame*: 1,508 performances; and *La Cage Aux Folles*: 1,761 performances.)

☞ **A 23.**

Stewart asked a physician friend if he could "give" him a sore throat. The doctor simply placed some bichloride of mercury in the actor's throat and then repeated the procedure the following day. That was enough to guarantee that Stewart would sound hoarse on the set.

☞ **A 24.**

The first time *South Pacific, Sweet Charity,* and *The Boy Friend* appeared on Broadway, none of them ran for

more than fifteen performances. Of course, the three famous musicals with the same titles, which were to follow years later, all ran for well over one thousand performances. But these first productions were plays: *South Pacific* was directed by Lee Strasberg (1901–1982) and lasted for five performances in 1943; *Sweet Charity,* directed by George Abbott (b. 1887), folded after the eighth performance in 1942; *The Boy Friend,* which starred Brian Donlevy (1889–1972), called it quits after fifteen performances at the Morosco Theater in 1932.

☞ **A 25.**

Until recently it was believed that D. W. Griffith (1875–1948) had invented the trucking, or dolly, shot in 1909. A few years ago, however, a similar shot was viewed in a film clip made in 1903 by Thomas A. Edison (1847–1931). The camera had been placed on the hood of a moving automobile, and it filmed two motorcycle cops chasing a runaway car along Riverside Drive in New York—then devoid of any structures except Grant's Tomb. (Apparently, there was nothing else but the chase captured in this 1903 film clip.)

☞ **A 26.**

Alec Guinness (b. 1914).

☞ **A 27.**

Yes. Welles (who incidentally never attended any film classes) made a one-reel motion picture called *The Hearts of Age* in 1934 when he was nineteen on the campus of his alma mater, the Todd School for Boys, in

ANSWERS

Woodstock, Illinois. Virginia Nicholson, who "starred" in it, became his first wife.

☞ **A 28.**

It happened in 1957, in London. Peter was played by British movie star Margaret Lockwood (1916–1990). Wendy was played by Lockwood's real-life daughter, June, who was sixteen years old at the time.

☞ **A 29.**

Arthur ("Dooley") Wilson (1886–1953) sang the song, which was first made popular by Rudy Vallee (1901–1986) in 1931, but he didn't know how to play the piano. The piano accompaniment heard on the sound track was played by Elliot Carpenter and dubbed in later. Incidentally, Wilson was the only member of the cast who had actually been in the real Casablanca—he had performed there in the 1930s at a soiree in honor of T. E. Lawrence (1888–1935).

☞ **A 30.**

In both, the entire male casts were nominated for Academy Awards: Laurence Olivier (1907–1989) and Michael Caine (b. 1933) in *Sleuth,* and James Whitmore (b. 1921) in *Give 'Em Hell, Harry.* (In *Sleuth,* two male bit players appear near the end but only for a very brief time.)

☞ **A 31.**

None. Cagney refused a fee out of respect for the memory of Eddy Foy (1857–1928), a friend from his younger days.

STAGE AND SCREEN

☞ **A 32.**

She became the manager of a movie theater in Copenhagen and died in 1972.

☞ **A 33.**

Noel Coward (1899–1973) said that to Claudette Colbert (b. 1905). A year later, Coward apologized for the remark in a conciliatory letter, and the two became friends again.

☞ **A 34.**

Pearl White ran a casino in Biarritz, France.

☞ **A 35.**

They were the only male movie stars to be nominated for Academy Awards after they had died. Peter Finch was the only one who actually won an Oscar posthumously—for *Network* (1976).

☞ **A 36.**

Thornton Wilder's *Our Town*. Wilder (1897–1975) also won Pulitzer Prizes for his novel *The Bridge of San Luis Rey* (1927) and the play *The Skin of Our Teeth* (1942).

☞ **A 37.**

The wreath encircles the famous MGM lion.

ANSWERS

☞ **A 38.**

Neither the cast nor crew of *Black Narcissus* ever left England. The outdoor shots of the Himalayas were filmed in a subtropical garden in the south of England. Images of the Himalayas were painted on glass for use in scenes throughout the picture.

☞ **A 39.**

An appraisal by New York film critic Rex Reed (b. 1938) of the Academy Award–winning documentary feature *Hearts and Minds* (1975), produced by Peter Davis and Bert Schneider. It dealt with the thoughts and fears of GIs during the Vietnam War.

☞ **A 40.**

George Burns (b. 1896) won an Academy Award for his 1978 role in *The Sunshine Boys.*

☞ **A 41.**

The Red Shoes, starring Moira Shearer (b. 1926). She later became a prima ballerina with the Royal Ballet Company.

☞ **A 42.**

Jazz drummer Buddy Rich (1917–1987).

STAGE AND SCREEN

☞ **A 43.**

Because she was bedridden, Taylor (b. 1932) was unable to accompany her third husband, producer Mike Todd (1909–1958), on a trip they had planned to take in their private aircraft in 1958. A few hours after take-off, the plane crashed, and Todd was killed.

☞ **A 44.**

Maria Augusta von Trapp (1905–1987), the mother of a family of singers who won world renown when they were portrayed in the Rodgers and Hammerstein musical *The Sound of Music.* In 1939, after escaping from the Nazis in Austria, they settled in the United States. The Oscar-winning movie version (1965) grossed over $200 million, but the von Trapp family—even though they were under contract—received very little of the gross income.

☞ **A 45.**

In 1940, five years after he retired from the screen, Tom Mix broke his neck in an automobile accident and died. Buck Jones was in the Coconut Grove nightclub in Boston on November 28, 1942, when a devastating fire killed 493 people. He escaped at first, but went back inside again and again to rescue people until he collapsed from sheer exhaustion and smoke inhalation. He never recovered and died shortly afterward.

☞ **A 46.**

Millicent Miller, who died at the age of 81 in 1990. She was Vivien Leigh's understudy.

ANSWERS

☞ **A 47.**

William Boyd (1898–1972). He portrayed the cowboy Hopalong Cassidy.

☞ **A 48.**

Nora Kaye (1920–1987) was first married to Isaac Stern (b. 1920) and later to Herbert Ross (b. 1927), who made *The Turning Point,* a movie about ballet dancers. Many ballets were created for Nora Kaye, including Anthony Tudor's *Pillar of Fire,* Agnes de Mille's *Fall River Legend,* and Jerome Robbins's *The Cage.*

☞ **A 49.**

W. C. Fields (1880–1946). His contract was terminated because of his impossible behavior on the set, most of it brought on by alcoholism.

☞ **A 50.**

Earle Hyman (b. 1926), who also played Cliff Huxtable's father on the television sitcom "The Cosby Show."

☞ **A 51.**

They all played the unusual part of an empress: Powers played the Holy Roman empress Matilda in *Becket,* 1964; Kruger, the Austrian empress Maria Theresa in *Marie Antoinette,* 1938; Gardner, Empress Elisabeth of Austria-Hungary in *Mayerling,* 1968; Oberon, Empress Josephine

STAGE AND SCREEN

of the French in *Desirée,* 1954; Sondergaard, Empress Eugénie of the French in *Juarez,* 1939; Davis, Empress Carlota of Mexico in *Juarez,* 1939; Bankhead, Catherine II, Empress of All the Russias (who was also portrayed by Bette Davis in *John Paul Jones,* 1959, and numerous other actresses in other films) in *A Royal Scandal,* 1945; Dunne, Queen Victoria of England, who was also Empress of India, in *The Mudlark,* 1950; and Robson, the dowager Empress Tsu Tsi of China in *55 Days at Peking,* 1963.

☞ **A 52.**

They each played a classical composer: Henreid played Schumann in *Song of Love,* 1947; Walker, Brahms in *Song of Love,* 1947; Curtis, Schubert in *New Wine,* 1941; Bassermann, Beethoven in *New Wine,* 1941; Wilde, Chopin in *A Song to Remember,* 1945; Aumont, Rimsky-Korsakov in *Song of Scheherazade,* 1947; Chamberlain, Tchaikovsky in *The Music Lovers,* 1971; Howard, Wagner in *Ludwig,* 1973; Bogarde, Liszt in *Song Without End,* 1960; and Hulce, Mozart in *Amadeus,* 1984.

☞ **A 53.**

Suzanne Farrell (b. 1945), longtime principal of the New York City Ballet. When she temporarily left the company in 1970, George Balanchine declared, "I've lost my muse."

☞ **A 54.**

George S. Kaufman (1889–1961). Among his biggest hits were *The Man Who Came to Dinner* and *You Can't Take It*

ANSWERS

With You (on both he collaborated with Moss Hart), *Merton of the Movies* (with Marc Connelly), *Stage Door* and *The Royal Family* (with Edna Ferber), *Animal Crackers* and *A Night at the Opera* (with Morrie Ryskind, for the Marx Brothers), *The Solid Gold Cadillac* (with Howard Teichmann).

☞ **A 55.**

In May 1970, a pair of sequined ruby-red slippers was auctioned for $15,000; they are now in the Smithsonian Institution in Washington, D. C. In June 1988, another pair of crimson, low-heel shoes, size 6B, was auctioned at Christie's for the highest bid ever recorded for a piece of motion-picture memorabilia—$165,000. But whether Judy Garland (1922–1969) ever wore either of those two pairs in the movie is not actually known. MGM had seven or eight pairs of these slippers made for her and her stand-in. Some were lost, while others were used during rehearsals only.

☞ **A 56.**

Faulkner (1897–1962) wanted to work on either Mickey Mouse cartoons or newsreels. When he was not commissioned to work on either, but only on B-picture screenplays, he returned to Mississippi and wrote *Absalom, Absalom!* (1936), which did not sell any more copies than his earlier books, *The Sound and the Fury* (1929) and *Light in August* (1932). Eventually he returned to Hollywood to work for production chief Darryl F. Zanuck (1902–1979) of Twentieth Century Fox,

and there he made more money than he had ever
earned on his novels.

☞ **A 57.**

The Oscar for best supporting actress was handed to
Shelley Winters in the house in Amsterdam where Anne
Frank had hidden for twenty-five months before her
capture by the Nazis in 1944.

☞ **A 58.**

Lillian Gish (b. 1896) played in *The Unseen Enemy* in
1912 and *The Whales of August* in 1987. Milton Berle (b.
1908) was a child actor in the early Biograph movies in
1913 and performed in Woody Allen's *Broadway Danny
Rose* in 1984.

☞ **A 59.**

Marlene Dietrich deepened her already sunken cheeks
by having her upper rear molars removed.

☞ **A 60.**

Woody Allen (b. 1935).

☞ **A 61.**

Frederick Austerlitz was better known as Fred Astaire
(1899–1987).

ANSWERS

☞ **A 62.**

Leonard Bernstein (1918–1990).

☞ **A 63.**

Life with Father, which became the longest-running drama in Broadway history. It ran for 3,224 performances from November 8, 1939 to July 12, 1947. (The musical *A Chorus Line,* however, ran for many more years on Broadway.)

☞ **A 64.**

It was not a movie star but the innovative cinematographer Harold G. Rosson, who died in 1988, at age 93. Rosson won a special Academy Award (with Howard Greene) for his pioneering use of color in *The Garden of Allah* in 1936. He was also the cinematographer for *The Wizard of Oz* (1939), *Duel in the Sun* (1947), and *Singin' in the Rain* (1952). Jean Harlow divorced him in 1935 after an eighteen-month marriage because she did not like his habit of reading in bed.

☞ **A 65.**

Evensong, which was shot in England in 1933 with the Welsh playwright Emlyn Williams (1905–1987) and the Austrian actor Fritz Kortner (1892–1970) in the cast. Guinness was only nineteen years old at the time and was cast as an extra. His second film appearance occurred thirteen years later—his role in the 1946 film *Great Expectations* made him famous.

STAGE AND SCREEN

☞ **A 66.**

Harry Carey (1878–1947).

☞ **A 67.**

Mel Tormé (b. 1925). His unpublished novel was a 1955 Western called *Dollarhide.*

☞ **A 68.**

Alicia Alonso (b. 1921), who chose to remain in her native Cuba after the 1958 revolution, becoming one of its most popular artists, while her reputation as one of the great classical dancers of the century continued to grow unabated abroad.

☞ **A 69.**

Although many people credit Marlene Dietrich with being the first female star to wear pants in movies, it was actually Myrna Loy (b. 1905), who first wore them in *What Price Beauty?* in 1924.

☞ **A 70.**

All of them—at one time or another—starred in the seven-year Broadway run of *Hello, Dolly!* Pearl Bailey was initially offered the lead but turned it down. Carol

ANSWERS

Channing accepted the part immediately and received a Tony Award for her performance.

☞ **A 71.**

Emil Jannings (1884–1950) was born in Brooklyn of German parentage, and as an infant was taken to his grandparents in Germany. He won the first Academy Award ever presented for his performance in *The Way of All Flesh* in 1927. The performance for which he is best known, however, was opposite Marlene Dietrich in *The Blue Angel* (1930), which was based on Mann's novel *Professor Unrat*. Despite his several film performances, Jannings found he could not make a career as an actor in the U.S. because his German accent was so pronounced, so he eventually returned to Germany. Under the Nazis he enjoyed a successful stage and screen career, but after the Second World War he became an Austrian citizen. He died in Sankt Wolfgang.

☞ **A 72.**

Legend has it that she spoke for over half an hour. Actually she took only about six minutes, but gossip over the years added about thirty minutes to the speech's length.

☞ **A 73.**

Kiss My Firm but Pliant Lips was its title.

☞ **A 74.**

Ingrid Bergman (1915–1982). In the last year of her life, she filmed the television miniseries *Golda* in Israel in

which she portrayed the Israeli Prime Minister Golda Meir (1898–1978), who had suffered from leukemia for the last fourteen years of her life. Suffering from breast cancer herself while filming, Bergman died shortly thereafter, on her sixty-seventh birthday.

☞ **A 75.**

Pola Negri (1899–1987), one of the greatest silent movie stars. She returned to America in 1941, made *The Moonspinners* for Walt Disney in 1964, and lived out the rest of her life in San Antonio, Texas.

☞ **A 76.**

Because Sam Warner died the day before the premiere.

☞ **A 77.**

Clark Gable (1901–1960) and Humphrey Bogart (1899–1957), but both of them had died before he could find a studio that would back the project. He had been trying to film it for twenty years.

☞ **A 78.**

Greta Garbo (1905–1990). Mayer, the head of MGM Studios, made his offensive remark when Garbo did not show up to marry Gilbert. Gilbert's career was eventually ended by the arrival of sound movies; his voice often sounded affected and too high. Even so, Garbo had him cast opposite her in *Queen Christina* in 1933. Gilbert suffered a heart attack and died in 1936, at age thirty-eight.

ANSWERS

☞ A 79.

Clara Bow, the "It" Girl (1905–1965). She was watching the 1929 Western *The Virginian* when she died of a heart attack. The star of the movie was Gary Cooper (1901–1961) and the director was Victor Fleming (1883–1949).

☞ A 80.

Marilyn Monroe (1926–1962) and Ronald Reagan (b. 1911). When David Conover discovered her in June 1945, Monroe was Norma Jean Dougherty, nineteen years old. All that is left of those pictures are ten photos and fifteen transparencies.

☞ A 81.

John Van Druten's (1901–1957) original play, *I Am a Camera,* was based on Christopher Isherwood's (1904–1986) *Berlin Stories,* and the actress who won the Tony was Julie Harris (b. 1925). The musical based on the play was called *Cabaret,* and in the 1972 movie version Liza Minnelli (b. 1946) won the Academy Award for her performance as Sally Bowles, the same part Julie Harris had played—without the singing—twenty years before.

☞ A 82.

These three Warren Beatty (b. 1937) motion pictures were nominated for Academy Awards in both acting

and writing, among other categories, yet never won an Oscar in either of these two fields. Nevertheless, each of these three films won Academy Awards for other cinematic achievements.

☞ A 83.

Adriana Caselotti sang the role of Snow White in Walt Disney's 1937 classic *Snow White and the Seven Dwarfs.* Disney's first choice for the singing part had been Deanna Durbin (b. 1921), but when he heard Caselotti's voice on records he changed his mind. (In the 1930s, it was not the custom of Disney or other cartoon studios to put the name of the dubbers on their screen credits. Even Mickey Mouse, dubbed by Disney himself, was never identified on the credits with Disney's name.)

☞ A 84.

Janet Gaynor. She was nominated for her starring roles in three 1927 movies—*Sunrise, Seventh Heaven,* and *Street Angel*—and received the first Academy Award ever presented to an actress for her performance in *Seventh Heaven.* The awards ceremony at that time was so intimate that it was not even broadcast.

☞ A 85.

It was indeed an impossible feat. The person seen crawling up the stairs was not Marshall at all but a double, whose facial features were blurred since the camera was focusing on the icy expression of Bette Davis, who was

in the foreground. The double slipped into Marshall's place when the latter was momentarily offscreen.

☞ A 86.

(1) Robert Redford (b. 1937); (2) Warren Beatty (b. 1937); (3) Sean Connery (b. 1930); (4) Rock Hudson (1925–1985); (5) Greta Garbo (1905–1990); (6) Charles Bronson (b. 1922).

☞ A 87.

Gig Young (1917–1978) killed his young bride, Kim Schmidt, and then shot himself.

☞ A 88.

The Gay Divorce on Broadway became *The Gay Divorcee* (1934) in Hollywood, because, while a divorced person might conceivably be cheerful, the movie industry considered it improper to suggest that there could be anything merry about a divorce! In this Cole Porter musical, the song "Night and Day" was introduced by Fred Astaire.

☞ A 89.

The actor who does not belong is Edward G. Robinson (1893–1973). All the others played the part of the devil in a movie.

☞ A 90.

(1) *Stagecoach* (1939); (2) *Mr. Deeds Goes to Town* (1936); (3) *The Roaring Twenties* (1939).

STAGE AND SCREEN

☞ **A 91.**

The director was William Wyler (1902–1981), who directed Bette Davis in *Jezebel* in 1938 (which won her an Oscar), *The Letter* (1940), and *The Little Foxes* (1941).

☞ **A 92.**

The most expensive Western up to that time, *Cimarron*, starring Richard Dix (1894–1949) and Irene Dunne (1898–1990). It was directed by Wesley Ruggles (1889–1972) in 1930.

☞ **A 93.**

Gloria Swanson (1899–1983). The picture she is best known for today is *Sunset Boulevard* (1950). One of her costars in it, Erich von Stroheim (1885–1957), directed her in the mid-twenties in a movie that almost bankrupted the financier, Joseph P. Kennedy, and was never released in the United States. A scene from that film was shown in *Sunset Boulevard.*

☞ **A 94.**

The name of Yves Montand (1921–1991). He was born Yvo Livi in Monsummano, near Florence, and his mother used to call, "Yvo, monta!" ("Yves, come up!") The family resettled in Marseilles after the Fascists came to power in Italy.

☞ **A 95.**

The name of the actress was Mae Busch (1897–1946), and the title of the first Laurel and Hardy talkie, in

ANSWERS

which she played opposite the two comedians, was *Unaccustomed As We Are* (1929).

☞ **A 96.**

When he was young, Harold Lloyd lost several fingers when a movie bomb went off in his right hand. (A movie bomb is a firecracker-like explosive device used to simulate an explosion—in Lloyd's case, it was supposed to simulate a hand grenade. Just as today's firecrackers are supposedly "safe," so the movie device of seventy years ago was known to misfire.) In most of his films, he wore a custom-made, flesh-colored glove. After his death it was revealed that a special two-story structure had been built on top of a fourteen-story building for the scenes in *Safety Last* in which Lloyd appeared to be dangling sixteen stories above the street. If he had fallen, it would only have been a few yards to the roof below, but the angle from which the scene was shot made it look as if Lloyd was truly risking his life. In the long shots, the stuntman Harvey Parry climbed up the outside of the building.

☞ **A 97.**

The entire series was filmed in the wilds of New York and New Jersey.

☞ **A 98.**

Comic actress Fanny Brice (1891–1951) said that about Eleanor Holm (b. 1913), the 1932 Olympic gold-medal

winner of the 100-meter backstroke and a star of many Hollywood aquatic movies.

☞ **A 99.**

Both titles are fictitious; they were actually "movies within a movie" in the Preston Sturges comedy *Sullivan's Travels* (1941) about a motion picture director, starring Joel McCrea (1905–1990) and Veronica Lake (1919–1973).

☞ **A 100.**

The Cosby Show. Bill Cosby's (b. 1937) wife, Camille, wanted the screen husband to be a medical doctor and his TV wife a lawyer, because she thought that the educational themes would work better if the parents were professionals.

☞ **A 101.**

Not Judy Holliday (1922–1965). The role of Billie Dawn was first played on the stage by movie star Jean Arthur (1901–1991). The play opened in New Haven, but by the time it reached Philadelphia she felt so insecure that she could hardly get out of bed. The producer, Max Gordon (1892–1978) and the playwright, Garson Kanin (b. 1912), tried a few other actresses, but none worked out. Finally, Kanin remembered having seen Judy Holliday in the nightclub group "The Revuers" and in a Broadway play called *Kiss Them for Me*. Holliday was rushed to Philadelphia where she learned the part in four days and became a star overnight. The original title of *Born Yesterday* (1946) was *A Little Knowledge*.

ANSWERS

☞ **A 102.**

Bogart replaced George Raft (1895–1980). Next in line after Bogart was Ronald Reagan (b. 1911).

☞ **A 103.**

Harry Houdini (1874–1926), who actually named himself after a nineteenth-century French magician, Houdin. Although he always claimed to have been born in Appleton, Wisconsin, he was probably born in Budapest. When he and his wife, Wilhelmina Beatrice Rahner, were vaudevillians in the mid 1890s, they often shared billings with Keaton's parents, who kept their baby in a trunk while they were on stage. When Joseph Francis was about six months old (1906), he fell out of the suitcase backstage, and Houdini exclaimed that the Keatons' baby sure took some buster, which at the time meant "something extraordinary" or "performing a noteworthy act," and ever since everybody referred to the boy (and later the movie star) only as "Buster."

☞ **A 104.**

Woody Allen first filmed *September* with Maureen O'Sullivan (b. 1911) in the role of Diane. He was dissatisfied with those scenes and decided to direct the whole thing again, but by that time O'Sullivan had come down with pneumonia, and so Elaine Stritch (b. 1926) took over the part.

☞ **A 105.**

Helen Hayes (b. 1900), Barbra Streisand (b. 1942), Rita Moreno (b. 1931), and Liza Minnelli (b. 1946).

☞ **A 106.**

László Szabó played a character named Richard Widmark in *Made in USA,* which was directed by Jean-Luc Godard (b. 1930) in 1966. It was a fictional character, based on the detective types portrayed by actor Richard Widmark (b. 1914).

☞ **A 107.**

Hello, Dolly!, which ran on Broadway for 2,844 performances.

☞ **A 108.**

In the novel, Rhett merely says, "My dear, I don't give a damn."

☞ **A 109.**

The comedians Bud Abbott (1895–1974) and Lou Costello (1908–1959) because of their comic sketch "Who's on First."

☞ **A 110.**

No, Johnny Weissmuller (1904–1984) was not in the cast. The two stars were Glenn Morris (1912–1974), the 1936 Olympic decathlon winner, playing Tarzan, and the 1932 gold medalist of the 100-meter backstroke, Eleanor Holm (b. 1913), playing Eleanor (no Jane in this film) in Fox's 1938 *Tarzan's Revenge.*

ANSWERS

☞ A 111.

The Divine Sarah—French actress Sarah Bernhardt (1844–1923). D. H. Lawrence (1885–1930) did not share Shaw's opinion of her. He called her "the incarnation of wild emotion, which we share with all living things."

☞ A 112.

All of them have played Catherine the Great in the movies. Moreau in *Catherine the Great* (1967), Dietrich in *The Scarlet Empress* (1934), Negri in *Forbidden Paradise* (1924), Dresser in *The Eagle* (1925), Bergner in *Catherine the Great* (1934), Bankhead in *A Royal Scandal* (1946), Neff in *Catherine the Great* (1962), Lindfors in *The Tempest* (1958), Davis in *John Paul Jones* (1959), Caldwell in *Catherine the Great: A Profile in Power* (1974). Mae West played her on the stage in *Catherine Was Great* (1944).

☞ A 113.

The second actor to play Iago was Welles's Mercury Theater colleague and *Citizen Kane* performer Everett Sloane (1909–1965), but since Welles was always short of money and worked on and off the film for almost four years (1948–1952), Sloane grew tired of the constant delays and left the production. The first Iago was an Italian actor, but no one seems to remember his name. MacLiammoir, incidentally, never played in another movie. *Othello* shared the top prize at the 1952 Cannes Film Festival with the Italian movie *Two Cents Worth of*

STAGE AND SCREEN

Hope but did not enjoy any critical success in the United States until the 1990s.

☞ A 114.

You can see these sequences in the Orson Welles production of Shakespeare's *Othello*. As Frank Brady explains in his book *Citizen Welles,* the movie was shot in slivers over a four-year period in Rome, Perugia, Venice, Morocco, and many other places, whenever Welles received new funds to continue its filming or when Welles himself wasn't acting in other people's pictures. That's how the actor portraying Iago (Michael MacLiammoir) is seen in the Venetian lagoon one moment and in the following frame off the coast of Africa. Likewise, Roderigo is seen kicking Cassio in Massaga, and maybe a year or two later Welles filmed the same actor being punched back a thousand miles away.

☞ A 115.

This popular place of entertainment is New York's Radio City Music Hall. The names given in the hint are the three architectural firms that designed the hall. It opened in December 1932.

☞ A 116.

Only once—in 1934 for *It Happened One Night.* The three award winners were stars Clark Gable (1901–1960) and Claudette Colbert (b. 1905) and director Frank Capra (1897–1991).

☞ **A 117.**

The actor who first played opposite Garbo in *Queen Christina* was Laurence Olivier. Garbo had seen and liked the then little-known British actor in the tear-jerking melodrama *Westward Passage,* but she became taut, or "frigid" as Olivier recalled, whenever he touched her during rehearsals of *Christina.* Since his part of Don Antonio de la Prada demanded a love scene with Garbo, MGM studio chief Louis B. Mayer (1885–1957) was finally compelled to accede to her demand that the male lead be played by Gilbert, whom Mayer detested.

☞ **A 118.**

The irony is that the first major role Garbo played in a Swedish motion picture was the part of Countess Dohna in *Gösta Berling* in the early 1920s.

☞ **A 119.**

The character's name was Jimmy Connors. He was portrayed by Mickey Rooney (b. 1920) in the 1940 musical *Strike Up the Band.* The tennis star was born in 1952.

☞ **A 120.**

Each of them has been married eight times.

☞ **A 121.**

The record for short marriages will have to go to Jean Arthur and the little-known Julian Ankar in 1967; it lasted exactly one day. A good runner-up is the mar-

STAGE AND SCREEN

riage of Michelle Phillips (b. 1944) and Dennis Hopper (b. 1936), which lasted for eight days in 1970.

☞ **A 122.**

Two of the most frequently quoted lines in *Casablanca* (1943's Oscar) were: "Here's looking at you, kid" and "Of all the gin joints in all the cities in all the world, she walks into mine." The Bogart toast to Bergman originally read, "Here's good luck to you, kid." The script writers originally phrased the second observation like this: "Of all the cafés in all the cities. . . ." Humphrey Bogart felt uncomfortable with those words and changed them himself on the studio floor.

☞ **A 123.**

Writers. Not all of them received screen credit.

☞ **A 124.**

The second movie that lists Margo Channing in the closing credits is *Sleuth* (1972). The credits show that Ms. Channing is supposed to be the name of the actress portraying the part of Marguerite, the wife of the lead played by Sir Laurence Olivier in the movie. However, Marguerite doesn't really appear in the film; she is only seen in a portrait, and her portrait resembles not Bette Davis but Joanne Woodward. Director Mankiewicz has deliberately made things even more confusing to the audience by calling Marguerite "Eve Channing" in the opening screen credits of this motion picture.

ANSWERS

☞ **A 125.**

Dean appeared in the early 1950s in the "U.S. Steel Hour," the "Kraft Television Theatre," and other television shows. Ironically, his last TV appearance was a 1955 film advocating safe driving that aired just a few weeks before he was killed in a car crash. Of the three movies that made him a cult figure posthumously, two—*Rebel Without a Cause* and *Giant*—were premiered (1956) only after his death. He enjoyed the success of just one of his own motion pictures: *East of Eden* (1955).

☞ **A 126.**

He was best known as Fatty (Roscoe) Arbuckle (1887–1933). The movie comedian was tried in the death of a starlet in 1921. Prosecutors maintained he had raped the woman with a Coke bottle. Though found not guilty, he never starred in movies again and became a motion picture director under a pseudonym.

☞ **A 127.**

Marlene Dietrich (1901–1992), who was ninety years old when she died. She spoke to her daughter, Maria Riva, on the telephone the day she died, although she could hardly speak anymore, and minutes before she died she whispered "Maria" twice, lying in her grandson's (Peter Riva, b. 1950) arms, the person who, with her daughter, was closest to her.

THE LITERARY
WORLD

☞ A 1.

Note: the most widely *used,* not *spoken,* language. The correct answer is the American sign language used by the deaf and mute.

☞ A 2.

The Chinese language.

☞ A 3.

Thomas Wolfe (1900–1938), Ernest Hemingway (1898–1961), John Dos Passos (1896–1970), Erskine Caldwell (1903–1987), and William Faulkner (1897–1962).

☞ A 4.

This was how Ernest Hemingway characterized Thomas Wolfe.

ANSWERS

☞ **A 5.**

In her book *A Key to Uncle Tom's Cabin,* Stowe wrote that the character of Uncle Tom was largely based on the life of Josiah Henson, a slave who escaped to Canada and then published his autobiography in 1848.

☞ **A 6.**

Thomas Paine's (1737–1809) pamphlet *Common Sense* (1776). This was followed by his influential tracts *The Crisis* (1776) and *The Public Good* (1780), which advocated a strong union under which states' rights should be subordinated.

☞ **A 7.**

Lou Andreas-Salomé (1861–1937). She was the great, and perhaps only, love of the unmarried Nietzsche. When his envious sister Elisabeth disrupted their relationship in the 1880s, the German philosopher became even more morose, a state of mind that was reflected in his last writings. After Nietzsche's death, Salomé became Rilke's mistress, and later still, a friend and disciple of Freud.

☞ **A 8.**

Though many might answer Rupert Brooke, that is not correct. Brooke did not die in action in WWI; he died of blood poisoning in 1915 and was buried in Skyros in the Aegean. Robert Graves (1895–1985) was so badly wounded during the battle of the Somme that his stretcher-bearer left him in a corner to die. Two days

after his parents had been notified of his death in action, he was well enough to send off a letter telling them that he was alive, and it reached them on his twenty-first birthday. Graves, who lived to be ninety, wrote a book about his generation's experiences in the First World War, *Goodbye to All That* (1929), as well as the famous historical novel *I, Claudius* (1934).

☞ **A 9.**

The author is Karl May (1842–1912). His books still sell by the millions every year in Europe, but he is virtually unknown in the United States. American critics consider him of little literary importance and without entertainment value, although many of his stories deal with life in the wild West, notably his three *Winnetou* novels.

☞ **A 10.**

The first printing of *The Day of the Locust* did not even sell 1,500 copies, although it was praised by some critics. The income from all four of West's novels totaled $1,280, and he was glad to get a screenwriting job with RKO for $350 a week.

☞ **A 11.**

Nathanael West (1903–1940), author of *Miss Lonelyhearts* (1933) and *The Day of the Locust* (1939). The title character of the long-running Broadway comedy *My Sister Eileen* by Ruth McKenney, which opened the week of the accident, was based on West's wife (portrayed in the movie by Janet Blair, born 1921). The writer whose death had upset West was F. Scott Fitzgerald (1896–1940).

ANSWERS

☞ A 12.

Giovanni Casanova (1725–1798). Only in the nineteenth century did he become famous, and more for his romantic feats than for the political, religious, and economic picture that he drew of Europe in his twelve-volume autobiography. Even though his grand-nephew sold the tome to the German publisher Brockhaus in 1821, a complete, unexpurgated version was not published until 1958–1961. Casanova preferred to call himself G.G.C., which stands for Giacomo Girolamo Casanova.

☞ A 13.

He didn't. Dante Alighieri (1265–1321) originally titled his work *Commedia.* The word *Divina* was not added to the title page until the sixteenth century, two hundred years after his death. Nobody knows exactly when Dante wrote *Commedia,* probably during the last twenty years of his life. It was first printed in 1472 in Mantua.

☞ A 14.

The first free public library in France was opened in the Georges Pompidou National Center for Art and Culture in Paris on January 31, 1977.

☞ A 15.

Many believe that she changed her name because of the difficulty for women at that time to break into the literary scene—which actually abounded with female novelists, such as the Brontë sisters. However, Evans's

main reason was that, like Jane Austen (1775–1817) who would not even affix her name to her novels, she valued her privacy above everything. She lived with her lover, author George Henry Lewes, for almost a quarter of a century, during which time she wrote *Adam Bede, The Mill on the Floss, Silas Marner* (all within three years), and *Middlemarch*. When Lewes died, she stopped writing; about six months before her own death in 1880, she married a friend of long standing, J. W. Cross.

☞ A 16.

The Communist newspaper *Daily Worker.* The comedy ran for a then record-breaking 3,224 performances.

☞ A 17.

Because the very next day, March 12, the Great Blizzard of 1888 dumped between twenty and thirty inches of snow on New York and the eastern seaboard. The wind piled up snowdrifts as high as thirty feet, and over the next three days about four hundred people died because of the storm.

☞ A 18.

The statue of Heine now stands in Joyce Kilmer Park, in the Bronx, New York. Not until 1981 did the Germans erect a bronze statue of Heine (by Bert Gerresheim) in his native town, Düsseldorf.

☞ A 19.

Evolution had already been discussed by Jean Baptiste de Lamarck and Darwin's grandfather, Eras-

ANSWERS

mus, before Charles was born. Charles Darwin started to write his *Notebooks on the Transmutation of Species* in July 1837 and in 1844 finished a treatise on the theory of evolution by natural selection, which he showed to the botanist Sir Joseph Dalton Hooker. He also summarized his theory in an 1857 letter to the American naturalist Asa Gray. When Darwin received Wallace's article detailing the simultaneously developed, identical theory in 1858, he immediately placed the article and, a few days later, his own 1844 treatise and a copy of the letter to Asa Gray, in the hands of the geologist Sir Charles Lyell (1797–1875) and the botanist Sir Joseph Dalton Hooker (1817–1911), who were both familiar with Darwin's earlier work. These two men decided to have the Wallace article and the Darwin treatise read as a joint paper at the Linnaean Society in London on July 1, 1858. Of overriding importance, however, are Wallace's own words in the preface to his work *Natural Selection* (Darwin's term), in which Wallace acknowledges that Darwin had been at work on *Origin of Species* long before he formulated his own ideas on the subject and that Darwin alone of all men was best fitted for the great work he had undertaken and accomplished. Only posthumously did the Royal Society recognize Darwin's preeminent contribution to science by establishing the Darwin Medal. Its first recipient was the cooriginator of the theory of evolution by natural selection, Darwin's friend Alfred Russel Wallace.

☞ **A 20.**

Over the years, this remark has been attributed to Hitler (1889–1945), Himmler (1900–1945), Göring (1893–1946), and Goebbels (1897–1945). Its actual origi-

nator was an unsuccessful playwright and little-known Nazi Party member, Hanns Johst, the president of the Reich Theater Chamber. He incorporated the remark into his 1933 drama *Schlageter.*

☞ A 21.

The novelist (and lyric poet) who is buried in two different places is Thomas Hardy (1840–1928). His ashes are buried in Westminster Abbey, in London, while his heart is buried in the Stinsford churchyard in Dorset. Max Gate is not the name of a man but of the house that Hardy had built for himself in 1883 and from which he rarely moved during the last forty-five years of his life.

☞ A 22.

Schutz's poetry appears on her own Blue Mountain Arts greeting cards. Millions of them have been sold over the last few years for all occasions. Her husband, Stephen (b. 1944), provides the illustrations for each of these greeting cards.

☞ A 23.

Albert Einstein (1879–1955) wrote these words to his Serbian coworker Mileva Maric in 1901. "Our" work referred to the relativity theory. The lovers shared classes at the Swiss Federal Polytechnic in Zurich, and later married and had children. Their love letters were published in 1987. After separating in 1914, Einstein paid her his Nobel Prize money as part of his alimony.

ANSWERS

Mileva, who died in 1948, never published a scientific paper under her own name.

☞ **A 24.**

Anne Rice, author of many books, including the well-known *Interview with the Vampire.*

☞ **A 25.**

Because Aeschylus (525–456 B.C) served as a foot soldier in the victorious Athenian army at the battle of Salamis and was therefore an eyewitness.

☞ **A 26.**

After the British invaded Washington and destroyed most of the 14-year-old Library of Congress in 1814, Jefferson, who was in dire financial straits, sold his personal collection of six thousand books to Congress in 1815 to restock its library. Historians claim that Jefferson's diverse literary interests set the tone for the library's liberal acquisitions policy. (A few books of his extensive library are housed in his estate in Monticello, Virginia, which is open to the public.)

☞ **A 27.**

Edward Aswell, a young Harper & Row editor, pieced together literary material from the huge body of work-in-progress Wolfe (b. 1900) left behind at his death in 1938. Aswell's efforts helped to produce *The Web and the Rock* (1939) and *You Can't Go Home Again* (1940).

Wolfe saw only two of his long novels published during his lifetime: *Look Homeward, Angel* (1929) and *Of Time and the River* (1935).

☞ **A 28.**

They were all right. Rear Admiral Bellinger and Lieutenant Commander Ramsey each sent out a message at 7:56 A.M. while the Japanese raid was going on (although perhaps Bellinger's message was read first).

☞ **A 29.**

At least partly on Guillaume Apollinaire (1880–1918), the proto-surrealist French poet.

☞ **A 30.**

George Orwell (1903–1950).

☞ **A 31.**

Berlin, Germany. Even during the racist Nazi period, the name of the subway station was never changed, and it is still called *Onkel Toms Hütte*.

☞ **A 32.**

No. Although he was eventually devoted to his Catholic faith, Chesterton (1874–1936) did not convert to Catholicism until he was close to fifty years old. What turned him into a rabid anti-Semite were the two most

ANSWERS

important influences of his life: his brother, Cecil, and his friend the English essayist Hilaire Belloc (1870–1953).

☞ A 33.

No. Indeed, Mencken solicited more African-American writers to publish material in the *American Mercury,* which he cofounded and edited, than any other editor of a white-owned journal. He railed against the Ku Klux Klan and was one of the earliest white supporters of the National Association for the Advancement of Colored People. Blacks were invited to write articles in the *Smart Set* magazine where he worked as a book reviewer while he wrote essays for the NAACP's *The Crisis.* In all fairness, it should also be pointed out that in spite of his occasional anti-Semitic remarks, Mencken was one of the first American columnists to attack the cruel treatment of Jews in Nazi Germany.

☞ A 34.

Nobody has ever been able to find this statement in any Chekhov play, story, essay, or letter.

☞ A 35.

Michael Harrington's (1928–1989) *The Other America.* Historians and politicians agree that no book since 1962 has had such an impact on the American social structure.

THE LITERARY WORLD

☞ **A 36.**

Benjamin Spock (b. 1903) won a gold medal for rowing in the 1924 Olympic Games in Paris. Representing the United States, he was number seven in the winning eight.

☞ **A 37.**

The Trial by Franz Kafka (1883–1924). The handwritten 1914 manuscript was sold at an auction in London in 1988 for $1.98 million, the highest price ever paid for a modern manuscript.

☞ **A 38.**

Edgar Allan Poe (1809–1849). When he was forty years old, he was found semiconscious on a street in Baltimore, Maryland. He died several days later, without revealing what had happened to him, although nowadays it is assumed he died of alcohol consumption and a weak heart.

☞ **A 39.**

Although the author of *All Quiet on the Western Front* is Erich Maria Remarque (1898–1970), the novel's last chapter was actually written by his first wife. This was revealed for the first time in 1987 in the autobiography of the controversial movie star and director Leni Riefenstahl (b. 1902). She had met Frau Remarque sev-

ANSWERS

eral times in the late 1920s and watched her carrying around her husband's manuscript and working on the last chapter. Frau Remarque claimed that her husband was too busy with his journalistic and teaching activities to complete the 1929 novel himself.

☞ **A 40.**

Jacob (1785–1863) and Wilhelm (1786–1859) Grimm, while still in their twenties, collected 242 folk and fairy tales altogether, which they edited and published (1812–1822), contending that they were actually Germanic versions of Indo-European myths. Jacob is also noted for his work on phonology, *Deutsche Grammatik* (1819–1822), which in two volumes—especially the second, revised volume—gave the first historical treatment of the Germanic and other Indo-European languages.

☞ **A 41.**

Lansdale was the model for Alden Pyle in Graham Greene's *The Quiet American* and for Edwin Barnum Hillandale in William Lederer and Eugene Burdick's *The Ugly American*. He also was the antihero of a French novel *Le Mal Jaune* (*Yellow Fever*), by Jean Larteguy.

☞ **A 42.**

When Gertrude Stein (1874–1946) went to pick up her car at a Paris garage she was told by the young mechanic that it was not yet ready. The proprietor of the garage lost his temper with the mechanic and

referred to him as a member of "la génération perdue." A short time later Stein repeated the phrase to Ernest Hemingway, telling him, "All you young people who served in the war, you are a lost generation."

☞ **A 43.**

He was one of the few recorded addicts who *injected* the drug, as described in the first chapter of Arthur Conan Doyle's (1859–1930) novel *The Sign of Four* (1889). Doyle never mentions Holmes's cocaine habit again.

☞ **A 44.**

Doyle invented the metal helmet and introduced cross-country skiing to Switzerland. In addition to the Sherlock Holmes stories, he wrote many novels as well as books about military campaigns, the causes of the First World War, and the history of spiritualism.

☞ **A 45.**

Altogether these three wrote more than 300 plays. Sophocles (495–406 B.C.) wrote 123 plays, according to the *Suidas* lexicon (A.D. 950–975). Euripides (484–407 B.C.) may have written as many as 92 plays. Seventy-eight of them were published at Alexandria by Aristophanes of Byzantium (ca. 257–180 B.C.), but that Euripides competed in 22 festivities of Dionysius suggests that he wrote 88 plays, and there are four others whose authenticity is in question. The total number of Aeschylus' (c. 525–456 B.C.) plays is stated in *Suidas* to have been 90.

☞ A 46.

Le Figaro dismissed the novel saying, "Monsieur Flaubert is not a writer." The French government went further and brought the author to trial on the grounds that *Madame Bovary* was immoral, and Flaubert barely escaped conviction. Six months later the same government tribunal found Charles Baudelaire (1821–1867) guilty of offending public morals in his collection of poems, *Les Fleurs du Mal.*

☞ A 47.

1984 by George Orwell (1903–1950).

☞ A 48.

It inspired him to write the novel *The Aspern Papers* in 1888.

☞ A 49.

It is remarkable that Blake (1757–1827) wrote the poems when he was between the ages of twelve and twenty.

☞ A 50.

After Tolstoy's sixth son died at the age of seven, the novelist began to find life with his unhappy, embittered wife, Sophia, unbearable. Her paranoia increased when Tolstoy's literary properties came under the control of

Chertkov, one of his religious disciples. In addition, Tolstoy's teachings of poverty and the renunciation of worldly goods were incompatible with his living in affluent Yasnaya Polyana. Finally, on October 28, 1910, Tolstoy left his home with his youngest daughter Alexandra and his loyal physician. He apparently had no specific destination in mind, except that he wanted to live out his days in a monastery. Less than two weeks after leaving his home he was dead of pneumonia at the railroad station of Astapovo. He was then eighty-two years old.

☞ A 51.

Those of John Stuart Mill (1806–1873).

☞ A 52.

Emile Zola (1840–1902) in his novel *L'Argent* (*Money*), which was published in 1891, and was decidedly anti-Semitic. When Zola came to the conclusion that Dreyfus was the innocent victim of a nefarious conspiracy, he had to overcome his prejudice. On January 13, 1898, Zola published his famous letter *J'accuse* in the newspaper *Aurore,* denouncing the French military for religious prejudice and stupidity. It rallied support for Dreyfus, who was eventually completely exonerated in 1906. Zola had never personally met Dreyfus.

☞ A 53.

Probably because his fellow countrymen were embarrassed by his ardent support of the Nazis before and during the Second World War. When Adolf Hitler

granted him a private audience, however, he was infuriated because Hamsun constantly interrupted him to complain about German conduct in occupied Norway.

☞ **A 54.**

They each wrote one novel. Jean Harlow's novel *Today Is Tonight* was published in 1934; Sarah Bernhardt's *In the Clouds* in 1878; H. L. Hunt's *Alpaca* in 1960; Mussolini's *Claudia Particella* in 1909 (translated into English and published in 1929 as *The Cardinal's Daughter*); Harry Reasoner's *Tell Me About Women* in 1946; Winston Churchill's *Savrola* in 1901; and Joseph Goebbels's *Michael* in 1929 (translated into English and published in the United States in 1987).

☞ **A 55.**

All's Well That Ends Well.

☞ **A 56.**

It was published in 1902, when the author was nine years old.

☞ **A 57.**

Apollo.

☞ **A 58.**

In the novels, George Smiley was a married man, even though his marriage was not a happy one. Sir Maurice Oldfield, on the other hand, had admitted to former

Prime Minister Margaret Thatcher (b. 1925) before his death in 1981 that he was a homosexual.

☞ **A 59.**

Emily Dickinson (1830–1886).

☞ **A 60.**

Francis Dickens, who had become a Royal Canadian Mounted Policeman, accepted an invitation to Moline, Illinois, to give a lecture about his novelist father. While eating a meal in Moline he had a seizure and probably choked to death. When the mayor of Moline cabled the news to the Dickens family in England, they decided to let him be buried where he had died.

☞ **A 61.**

Guy de Maupassant (1850–1893).

☞ **A 62.**

Two characters in *Point Counter Point* are based upon Sir Oswald Mosley (1896–1980), the British Fascist leader, and the writer D. H. Lawrence (1885–1930). The novelists Hugh Walpole (1884–1941) and Thomas Hardy (1840–1928) appear as fictional characters in *Cakes and Ale,* as does the painter Augustus John (1878–1961) in *The Horse's Mouth.*

☞ **A 63.**

"The $30,000 Bequest" by Mark Twain (1835–1910). Written in 1903, the story also reflects the depression

ANSWERS

and pessimism he felt during the last months of his wife's final illness.

☞ **A 64.**

She wrote many short stories, a few unsuccessful plays, some poems, and some articles; she is best remembered today for her mordant wit: Dorothy Parker (1893–1967).

☞ **A 65.**

Louis L'Amour (1908–1988). (In one of his obituaries, the thirty-three are listed, but none of them are well known.) L'Amour turned out dozens of best-selling novels about straight-shooting heroes of the Old West, many of them written under the pseudonym Tex Burns. He became the first author to receive a Congressional Gold Medal.

☞ **A 66.**

George Washington (1732–1799).

☞ **A 67.**

King James I of England (reigned 1603–1625). Even though the tract was published anonymously, everyone knew that it had been written by the king. He called smoking "lothsome to the eye, hatefull to the Nose, harmfulle to the braine, daungerous to the Lungs."

☞ **A 68.**

Saul Bellow (b. 1915), who also had to fulfill the six-week requirement for a divorce decree. While there, Bellow wrote part of his novel *Henderson the Rain King*.

☞ **A 69.**

Jomini's essays were first published in 1838, and they served as a textbook for officers of the American Civil War.

☞ **A 70.**

Joseph Goebbels (1897–1945), the German Nazi minister of propaganda. For twenty-one years he made a daily entry in his diary, filling thousands of pages about himself and the times he lived in, right up until the day he killed his six children and then committed joint suicide with his wife (May 1, 1945).

☞ **A 71.**

Ulysses by James Joyce (1882–1941) and *The Waste Land* by T. S. Eliot (1888–1965).

☞ **A 72.**

The one expression used in virtually every country in the world is "OK." Its earliest application was during the presidential campaign of 1840 in the United States. At

ANSWERS

that time, everybody of note seemed to be nicknamed "Old" something or other. When President Martin Van Buren (1782–1862) ran for reelection, he was nicknamed "Old Kinderhook," after his birthplace in New York State. Soon after, his supporters in New York formed the O.K. Club, and "O.K." became a rallying cry for Democrats. "Old Kinderhook" lost that election, but *OK* is more alive than ever.

☞ A 73.

The writer was Leo Tolstoy (1828–1910). He wrote these moving lines about his mother when he was eighty years old.

☞ A 74.

Through Arabic translations of the original Greek. The works of Aristotle, which had been well known to Islamic scholars while the West was still in the Dark Ages, were gradually discovered by the Christian West through contacts with Moslem Spain in the twelfth century.

☞ A 75.

Just one: the Book of Numbers is mentioned in *King Henry V* (I, ii, 98).

☞ A 76.

Shakespeare adapted *Venus and Adonis* and *The Rape of Lucrece* from *Metamorphoses* and *Fasti* of Ovid (43 B.C.–ca. A.D. 17).

☞ **A 77.**

Macbeth.

☞ **A 78.**

The Swiss psychiatrist Carl Gustav Jung (1875–1961). Jung, however, had already had his disagreements with Freud since 1912 about the importance of sexuality in relation to psychological problems. After the Second World War, Jung returned to Switzerland from Germany and criticized Nazi totalitarianism during the war.

☞ **A 79.**

The love story of Troilus and Cressida.

☞ **A 80.**

More than half of them were written by Alexander Hamilton (1757–1804); five of them were written by John Jay (1745–1829), who would become the first Chief Justice of the United States; and the rest by James Madison (1751–1836).

☞ **A 81.**

Cesare Borgia (1475–1507), son of Pope Alexander VI and his general in the papal states.

☞ **A 82.**

Frederick Schiller Faust wrote under the pen name Max Brand. He was one of the finest Western writers and had

ANSWERS

more than 150 novels published in his lifetime, including *Destry Rides Again* and his "Dr. Kildare" novels. He was killed on the Italian front while covering the Second World War for *Harper's* magazine.

☞ **A 83.**

Herman Melville (1819–1891).

☞ **A 84.**

One of the scriptwriters on each of these movies was the future Nobel Prize winner for literature William Faulkner (1897–1962). In some of these motion pictures—*Gunga Din* and *The Southerner,* for example—the studio heads dismissed his screenwriting as inadequate, and he received no screen credit for them. But many of Faulkner's own short stories and novels were turned into films, such as *The Tarnished Angels* (1957); *The Long, Hot Summer* (1958); *Tomorrow* (1972); *Intruder in the Dust* (1949); *The Sound and the Fury* (1959); *The Reivers* (1969).

☞ **A 85.**

Joseph Pulitzer (1847–1911). He died on his yacht, the *Liberty,* and was buried with a copy of the *New York World* at Woodlawn Cemetery in the Bronx, New York. From the enormous profits of his paper, the publisher had established the Pulitzer prizes.

☞ A 86.

Ghost stories are virtually nonexistent in Russian litera-
ture. The short story "The White Eagle," written in the
nineteenth century by Nikolai Leskov, is a notable
exception.

☞ A 87.

Note: The writer, Emile Zola, did not die of the flu but of
the *flue*—the defective flue in the bedroom of his Paris
house. There he was found in the morning of September
29, 1902, having been accidentally asphyxiated by the
fumes from this faulty shaft in the bedroom's chimney.

☞ A 88.

Heinrich Heine (1797–1856). After their marriage in
France in 1841, he changed his wife's name Crescentia
(which he considered too exotic) to Mathilde, and he
subsequently taught her how to read because she
wanted to acquaint herself with the works of Dumas.

☞ A 89.

Allegedly, Ralph Waldo Emerson (1803–1882), but the
statement appears nowhere in his published works.
However, in 1855 he wrote in his journal: "If a man has
good corn, or wood, or boards, or pigs to sell, or can
make better chairs or knives, crucibles or church

ANSWERS

organs than anybody else, you will find a broad hard-beaten road to his house, though it be in the woods."

☞ **A 90.**

Ada Byron (1815–1852), the daughter of the English poet Lord Byron, and later known as Countess of Lovelace. In her late twenties, her forty-page "Notes" was published in *Taylor's Scientific Memoirs* (1843), telling the early Victorian world about a revolutionary machine within man's grasp. She called it the Analytical Engine. Her thesis was discovered in 1953 by B. V. Bowden in Manchester, England, and her working instructions and programming analysis were so precise and correct that in 1979, a century and a quarter after her death, the United States Department of Defense named its new standardized computer language ADA in her honor. After giving birth to three children, Ada Byron died of uterine cancer at the age of 37.

☞ **A 91.**

Edgar Allen Poe (1809–1849). His young wife, Virginia Clemm, died at the age of 24 in 1847, an event that seemed to have hastened the author's total collapse. He memorialized Virginia, to whom he was devoted, in many poems, particularly in his "Annabelle Lee."

☞ **A 92.**

This line is taken from Donne's poem "To His Mistress Going to Bed," and it describes the precise moment when his lover's final article of clothing is cast off. Donne's work is frequently characterized by figurative

language and subtle imagery, and here he registered the wonder and awe that the Americas then sparked in European minds.

☞ A 93.

The name of this 1714 work is *Monadology*. Its writer was the German mathematician and philosopher Gottfried Wilhelm Leibniz (1646–1716). He wrote it in Latin, as he did virtually all his works, including the calculus, which he developed independently of and concurrently with Isaac Newton (1642–1727).

☞ A 94.

They are not in any well-known work of fiction. Certainly not in *Gone With the Wind*. Margaret Mitchell (1900–1949) only wrote *these* parting words to Scarlett O'Hara: "My dear, I don't give a damn." The word "frankly" was added by Clark Gable (1901–1960) himself in the 1939 motion picture.

☞ A 95.

It is the annual *Guinness Book of Records,* which has sold, worldwide, about 65 million copies in dozens of languages since the late 1950s.

☞ A 96.

Dame Barbara Cartland (b. 1904). About 550 of her novels have been published. Her other record is that she

ANSWERS

has consistently had about eight novels published every year for over seventy years, her first published work being the novel *Jigsaw* in 1921.

☞ **A 97.**

Benchley and Hitler both were born and died in the same years—1889 and 1945. Benchley assumed the pseudonym of Guy Fawkes (1570–1606), who was accused of joining the Gunpowder Plot (1605) to blow up King James I (1566–1625) and the members of both Houses of Parliament, when writing a column called "The Wayward Press" for the *New Yorker*, for which he was also the drama critic in the 1930s.

☞ **A 98.**

Mathematically it is incorrect because subtracting sixty pennies from one dollar and eighty-seven cents leaves the heroine of the story, Della, one dollar and twenty-seven cents. What about those two extra pennies that O. Henry seemed to ignore? It is hard to imagine that both the writer and his editor totally disregarded the two outstanding pennies. But, in actuality, nothing is wrong: There was an American two-penny coin, minted between 1864 and 1873 and still in circulation and legal tender (much like today's two-dollar bill) when the author wrote the classic, which appeared in 1909 in a volume of his short stories entitled *The Four Million.*

☞ **A 99.**

If your answer is that the mistake is the missing period after Truman's initial S, you are wrong. There is no

grammatical or factual error in the sentence. The middle initial S was a compromise between the names of his two grandfathers, Anderson Shippe and Solomon Young. As his daughter Margaret Truman-Daniels (b. 1924) maintained in the biography of her father, Harry's parents added an S to placate their touchy elders, but they refrained from deciding whether it stood for Solomon or Shippe. Therefore, the middle initial stood for nothing. Later it was the grammarians who argued over whether or not to use a period after the initial S. HST himself didn't care. Sometimes he left the period out when signing his full name, and occasionally he used it.

☞ **A 100.**

Carol Matthau (b. 1925), wife of actor Walter Matthau (b. 1920). Ms. Matthau wrote her memoirs, *Among the Porcupines,* in 1992.

☞ **A 101.**

Peter Mark Roget's (1779–1869) *Thesaurus of English Words and Phrases,* first published in 1852 when Roget was seventy-three years old. Today the book is known as *Roget's International Thesaurus,* although it is popularly referred to as *Roget's,* or the *Thesaurus,* which means treasury or warehouse, a derivative of the Latin and Greek word for storehouse.

MUSIC

☞ **A 1.**

If you can recite the first line of the Spanish national anthem, you know more than the Spanish do, because the anthem has no official words—just like the national anthems of Mauritania and the United Arab Emirates. Even the composer's name is unknown. However, on March 3, 1770, Carlos III (1716–1788) declared it the "Spanish Royal March" by royal decree. In July 1942 General Franco (1892–1975) issued a decree declaring it the official national anthem of Spain.

☞ **A 2.**

Nobody knows why it was called the *Emperor*. Beethoven certainly did not dub it that, since by the time he finished it in 1810, his antagonism toward Napoleon was extremely strong, although originally he had meant to dedicate the concerto to him. An uniden-

ANSWERS

tified publisher named it *Emperor,* but nobody knows whether he did so in honor of Napoleon or because he was inspired by the overall majesty of the music itself. The concerto was premiered in Leipzig in 1810. When it was performed in Vienna in 1812, Beethoven's deafness had become so acute that he could no longer play the piano in public (except one more time in 1814, when he made a great impression with his B-flat trio, op. 97). The 1812 soloist of the *Emperor* Concerto was Karl Czerny (1791–1857), a student of Beethoven's, who later became the teacher of Franz Liszt (1811–1886).

☞ **A 3.**

During World War II, George Balanchine (1904–1983) commissioned Igor Stravinsky (1882–1971) to compose a piece entitled "Circus Polka." It was actually "danced" to choreography by Balanchine in 1942, by a troupe of fifty very young elephants of the Ringling Brothers Circus.

☞ **A 4.**

The Austrian's name was Richard Tauber (1891–1948). In the forties, he became a naturalized British subject. When he died in 1948, he owed people large amounts of money, and Marlene Dietrich (1901–1992) paid his debts.

☞ **A 5.**

The conductor was Leonard Bernstein (1918–1990), of the New York Philharmonic. Glenn Gould (1932–1982) was the soloist of the Brahms Piano Concerto in D Minor, op. 15, at a concert in the 1960s. Although Gould's interpretation of the piece was to play it at an uncommonly slow tempo, the conductor decided to

MUSIC

lead the orchestra anyway, in a "spirit of adventure." The irony is that many years later, in the 1980s, Bernstein conducted the same concerto with the Polish pianist Krystian Zimerman, at an even slower pace.

☞ A 6.

If your answer is Schiller and the symphony's lyrics his poem "Ode to Joy" ("An die Freude"), you are only half right. Beethoven himself wrote the opening words for the bass: "O friends, not these sounds! Rather let us intone pleasanter and more joyful ones." Even more noteworthy, the composer used only half of Schiller's 1803 version of the poem and rearranged and reworked these nine sections in accordance with his own flair for the dramatic and poetic—so much so, in fact, that Maynard Solomon, one of the world's most renowned Beethoven scholars, felt that the composer virtually wrote his own text to the Ninth Symphony's "Ode to Joy."

☞ A 7.

In 1937 Friml reissued "Chansonette" as "The Donkey Serenade." Duke Ellington changed his song's title in 1943 to "Don't Get Around Much Any More." And Irving Berlin made his 1917 song famous in 1933 by renaming it "Easter Parade." Only after the changes in titles or lyrics did these three songs become world famous.

☞ A 8.

Because the character is Brünnhilde's horse, Grane. She rides off to her fiery death at the end of the Ring of the Nibelung in *Götterdämmerung*.

ANSWERS

☞ **A 9.**

This statement was made by conductor Arturo Toscanini (1867–1957) about Beethoven's Third Symphony, the *Eroica*.

☞ **A 10.**

During the world premiere of Alexandr Nikolayevich Scriabin's (1872–1915) *Poem of Ecstasy* in New York in 1908. Colored lights were reflected on a screen behind the piano in the huge orchestra. Incidentally, the musical composition ends with one of the loudest chords in classical music.

☞ **A 11.**

The symphony that was rejected by the Viennese orchestra was Franz Schubert's (1797–1828) Ninth Symphony in C Major. After receiving it from Schubert's brother Ferdinand, Robert Schumann (1810–1856) saved the symphony from oblivion.

☞ **A 12.**

The answer is snow. For about half a century Bing Crosby's voice has been heard throughout the Western world singing Irving Berlin's (1888–1989) "White Christmas."

☞ **A 13.**

All four premieres were conducted by Arturo Toscanini (1867–1957). But from Toscanini's correspondence,

MUSIC

it is apparent that the conductor did not admire some of these operas as much as some of Puccini's others.

☞ A 14.

If your answer is Rossini, Puccini, Vivaldi, and Mozart, you are only partly right. A *Barber of Seville* was also written by Giovanni Paisiello (1782); a *Bohème* by Ruggiero Leoncavallo (1897); a *Four Seasons* by Alexander Glazunov (1915) and Benedetto Marcello (1731), and as a cantata (now lost) by J. S. Bach. *Don Giovanni* was also an opera composed by Giuseppe Gazzaniga in 1787, the same year in which Mozart wrote his own *Don Giovanni*. A further irony is that the librettist for both *Don Giovanni*s was Lorenzo da Ponte (1749–1838), who also worked with Mozart on *The Marriage of Figaro* and *Così Fan Tutte*.

☞ A 15.

A composition that can claim kinship to Bach's Goldberg Variations is Beethoven's Thirty-three Variations on a Waltz by Diabelli. This kinship is especially conspicuous in Beethoven's thirty-first variation and Bach's twenty-fifth.

☞ A 16.

Because the word *oratorio* implies a biblical content, and Schweitzer felt that this was entirely lacking in the *Christmas Oratorio*.

ANSWERS

☞ **A 17.**

It was Mozart's English music publisher, Johann Baptist Cramer, who coined the name *Jupiter* for Mozart's Forty-first Symphony. Cramer, esteemed as a pianist by Beethoven, composed the famous *Etudes* for the training of pianists. They still rank among the finest works of their kind ever written and are still used by piano teachers today.

☞ **A 18.**

Somebody else's: the voice of Andy Williams (b. 1930).

☞ **A 19.**

David Bowie (b. 1947).

☞ **A 20.**

Because Wagner felt that there was no opera house already existing in Germany fit for so colossal a work as his recently completed *Der Ring des Nibelungen*.

☞ **A 21.**

The singer Dinah Washington (1924–1963).

☞ **A 22.**

He wrote the theme song of all the *Ziegfeld Follies* productions: "A Pretty Girl Is Like a Melody."

MUSIC

☞ **A 23.**

"The Song of the Birds"—a composition by Casals based on a Catalonian folk song.

☞ **A 24.**

The composer was Maurice Ravel (1875–1937) and the composition was "Boléro," originally titled "Fandango." Ravel changed the title a while after completing the piece.

☞ **A 25.**

One of his earliest compositions, his First Symphony in C Major, composed in 1833. Wagner conducted it in Venice in the Liceo Marcello on Christmas Eve, 1882; he died only two months later.

☞ **A 26.**

None, so far as we know. He never identified any tragedy in conjunction with this work.

☞ **A 27.**

It was an eight-inch plaster model of a torso. Honegger believed it to be a copy of a model long thought to have been destroyed in a 1690 fire in the Palazzo Vecchio in Florence. Not until 1987 did the Renaissance scholar Frederick Hartt discover that it was not a copy but the actual model used by Michelangelo for his great statue

ANSWERS

of David. Other Renaissance scholars believe that Michelangelo (1475–1564) himself made the model.

☞ A 28.

In 1909 Irving Berlin spent a hundred dollars on a stand-up composing piano built especially for him. Made by the Weser Bros. of New York, it contained a clutch mechanism that allowed the composer to sample any key he wanted. On this piano he composed more than a thousand songs, making him perhaps the most prolific and popular tunesmith ever.

☞ A 29.

The champion of concertos was Antonio Vivaldi (1678–1741). He wrote 488 of them. (Igor Stravinsky claimed he wrote just one concerto 488 times.) Boccherini (1743–1805) turned out 137 string quintets. The most prolific composer for the flute was better known for his military conquests—Frederick the Great of Prussia (1712–1786). He composed 120 flute concertos.

☞ A 30.

Ira Gershwin (1896–1983), who received the Pulitzer Prize in 1931 (with playwrights George S. Kaufman and Morrie Ryskind) for *Of Thee I Sing.* His brother, George (1898–1937), was the composer.

☞ A 31.

The Finnish composer Jean Sibelius died at the age of ninety-two (1957), as did American composer-

MUSIC

songwriter Rudolf Friml (1972). Robert Stolz, the Austrian composer of operettas, lieder, and film music, was ninety-four (1975). The American composer and painter Carl Ruggles (1876–1971) was ninety-five, and Pablo Casals, better known for being a cello virtuoso, died at the age of ninety-six (1973). The oldest of the world's well-known composers was Irving Berlin. When he died in 1989, aged 101, he had not actually published any new music for almost three decades.

☞ A 32.

Jazz clarinetist Benny Goodman (1909–1986).

☞ A 33.

The answer is none. Since 1901, there have been only guest conductors. Although the Vienna Philharmonic is the official orchestra of the Vienna State Opera, the musical director is appointed by the board of the opera house. All the administrative responsibilities of the music director are handled by orchestra players elected by their colleagues.

☞ A 34.

All four of them went blind late in life. In fact, the same doctor operated unsuccessfully on both Bach and Handel.

☞ A 35.

Ludwig (Ritter) von Köchel, who prepared a thematic catalog of Wolfgang Amadeus Mozart's works. While

ANSWERS

music by other composers is identified by opus numbers, Mozart's compositions are organized in the Köchel catalog and referred to as "Köchel (or just "K.") Number" so-and-so.

☞ A 36.

Havergal Brian, who was born in 1876 in Dresden, Staffordshire, England. Of his thirty-two symphonies, he turned out twenty-two after the age of eighty. He died in 1972, at age ninety-six.

☞ A 37.

Johann Sebastian Bach (1685–1750), who became totally blind in 1749 and was no longer able to compose. When he played for Frederick the Great in Potsdam in 1747, the king knew of his expertise as a clavier and organ player, but knew little of his compositions. After Bach died, the manuscript works were distributed among his sons, who, through indifference and carelessness, lost a great many of them. The composer who had shunned Bach was Handel (1685–1759).

☞ A 38.

It is not possible to establish the exact amount of time that goes by between *Das Rheingold* and *Götterdämmerung*. But from the youth of Wotan to the death of Siegfried, about three generations can be said to pass, or approximately seventy-five years. (Wagner would

not have agreed with this estimate. According to him, the tetralogy extended from the beginning of the world to its end.)

☞ **A 39.**

Tchaikovsky did not name his Sixth Symphony; however, it is known today as the *Pathétique*. It got that name years after the composer's death. On its first performance, on October 28, 1893, in St. Petersburg, the unnamed symphony got a mediocre reception. Ten days later Tchaikovsky was dead. Although the public was made to believe that he had died of an attack of cholera, he had actually taken arsenic rather than face public disclosure of an earlier homosexual affair.

☞ **A 40.**

Arguments as to who wrote these six concertos have persisted for decades. At first they were attributed to Giovanni Battista Pergolesi (1710–1736). Then musicologists believed that the composer was the man who edited the first version of the score, Carlo Ricciotti (1681–1756). Over the years, it has been conjectured that the composer was, variously, Handel, Vivaldi, Willem de Fesch, Johann Adam Birkenstock, and Fortunato Chellerie. Finally, the Dutch musicologist Albert Dunning succeeded in identifying the composer as the Dutch nobleman Unico Wilhelm Count van Wassenaer (1692–1766), a man active in the diplomatic, military, and commercial worlds. In the 1970s, Dunning discovered a manuscript copy of the concertos written

ANSWERS

in the first half of the eighteenth century, in the Wassenaer palace at Twickel, in Holland. No other compositions by Wassenaer have ever been found.

☞ A 41.

Franz Joseph Haydn (1732–1809) in 1796 and Johann Nepomuk Hummel (1778–1837) in 1804.

☞ A 42.

Turkey. Their military band is called the Mehter Band, and it dates back to the sixteenth century. Today, the band members still wear the uniforms that made them look strange four hundred years ago. The sleeves of their costumes are puffed out, and their pants look like multitiered, old-fashioned pairs of knickerbockers.

☞ A 43.

In a letter to his sister, Mozart wrote that directly after the world premiere of the *Paris* Symphony in June 1778, he had a large ice, said the rosary, and went to sleep.

☞ A 44.

The composer was much better known as one of the world's greatest conductors: Walter Damrosch (1862–1950). His rarely performed opera was *The Man Without a Country,* based on the famous novel by Edward Everett Hale (1822–1909).

MUSIC

☞ **A 45.**

Nobody. Franz Schubert (1797–1828) wrote incidental music to the romantic drama *Rosamunde, Fürstin von Zypern* by Hermina von Chézy, but the universally performed *Rosamunde* overture is actually one that Schubert composed for *Die Zauberharfe* in 1820. For the world premiere of *Rosamunde* on December 20, 1823, Schubert used the overture to his *Alfonso und Estrella* (February 1822).

☞ **A 46.**

The composer was Giacomo Puccini (1858–1924), and the opera was *Turandot*. At the La Scala premiere in 1926, Arturo Toscanini, who was conducting, turned to the audience at the end of the unfinished score and said, "Here the maestro put down his pen." Another composer, Franco Alfano, later completed the opera using sketches left by Puccini.

☞ **A 47.**

All of these composers wrote their own libretti for their operas.

☞ **A 48.**

Beethoven gave this explanation: "Thus Fate comes knocking at the door." During World War II these four notes were used to signify victory for the Allies. They

ANSWERS

were heard regularly on the BBC, performed on a ket-
tledrum, as a time signal between news broadcasts. The
rhythm—three short notes followed by one long—is the
same as that of the letter "V" in Morse code, and "V"
was the widely understood symbol of "victory" for the
Allies.

☞ A 49.

The same tune appears in all of these (and many other)
compositions. It is the melody of Great Britain's
national anthem, "God Save the Queen."

☞ A 50.

Poland's Ignace Jan Paderewski (1860–1941) and
Frédéric Chopin (1810–1849). Paderewski was also
a pianist and the first prime minister of the newly
independent Poland from 1919 to 1921. Until 1992
Paderewski's body was buried in the Battleship Maine
memorial in Arlington, Virginia. But since July 5, 1992,
his body has been interred at the St. John Cathedral in
Warsaw, Poland. His heart, however, is still buried at
the Shrine of Our Lady of Czestochowa in Doylestown,
Pennsylvania. Chopin's heart is buried in a Warsaw
cemetery, but his body is interred in Père-Lachaise
cemetery in Paris.

☞ A 51.

The United Kingdom of Great Britain and Northern
Ireland. It is the melody of "God Save the Queen."

MUSIC

☞ **A 52.**

Thomas "Fats" Waller (1904–1943), one of the greatest jazz pianists of all time.

☞ **A 53.**

The victim was the famous twelve-tone composer, Anton von Webern (1883–1945). He was shot at 9:45 P.M. outside his son-in-law's house in the Austrian village of Mittersill because he didn't heed the sentry's warning to stop walking. The sentry suffered from acute guilt for the rest of his life and died in the mid-1960s in a sanatorium.

☞ **A 54.**

Walter Lord, the author of *A Night to Remember,* contests the popular belief: "It has been accepted, with no basis in fact, that the band played 'Nearer My God to Thee.' . . . For one thing, the hymn is set to different music in America and in Britain." Now, as far as can be determined, the melody was the popular British waltz "Songe d'Automne" ("Dream of Autumn"). It had to be something all the musicians knew how to play without sheet music.

☞ **A 55.**

The "new" version of *Messiah* was composed by Wolfgang Amadeus Mozart (1756–1791). The instrument he

introduced was the clarinet, which had not been per-
fected during Handel's lifetime (1685–1759).

☞ A 56.

The composer Charles Ives (1874–1954). Today he is
considered America's greatest classical composer. The
earliest of the modernists, he had already composed
atonal compositions by the turn of the century, long
before Schönberg and Stravinsky did. But not even the
Encyclopaedia Britannica gave Ives an entry of his own
until the 1980s.

☞ A 57.

The Viceroy of Egypt, Khedive Ismail, commissioned
Giuseppe Verdi (1813–1901) to write an opera for the
occasion; the result was *Aïda*. Verdi finished it in time,
but it was not performed until December 24, 1871,
because the Franco-Prussian War delayed the construc-
tion of the scenery in Paris. Instead, another Verdi
opera, *Rigoletto,* was performed at the new Cairo Opera
House in 1869. Verdi himself never traveled to Egypt; he
was afraid he might be mummified and never make it
back to Italy.

☞ A 58.

These harsh opinions were recorded in the diary of
Piotr Ilich Tchaikovsky (1840–1893).

☞ A 59.

In Ludwig van Beethoven's (1770–1827) *Fidelio* and
Giacomo Puccini's (1858–1924) *Girl of the Golden West.*

MUSIC

☞ **A 60.**

The first two hammer blows in Gustav Mahler's
(1860–1911) Sixth Symphony symbolized the anti-
Semitism to which he was subjected in Vienna, and the
loss of one of his daughters, Maria (b. 1902), who died
of scarlet fever in 1907. He kept these two hammer
blows in the symphony, which he completed in 1904,
but removed the third hammer blow that symbolized
his heart disease, considering it too self-indulgent.

☞ **A 61.**

Franz Liszt's daughter, Cosima, was actually the mother
of Richard Wagner's three children. What they had in
common was that all four of them were born out of wed-
lock. In fact, Cosima was still married to Wagner's prin-
cipal conductor, Hans von Bülow, when she gave birth
to Isolde, Eva, and Siegfried. She didn't marry Wagner
until a year after Siegfried's birth, in 1870.

☞ **A 62.**

The title of the song is "I Will Never Turn My Back on
You." The singer is known as Big Maybelle (1924–1972).

☞ **A 63.**

Because Alessandro Moresci was the last castrato, and
the pope thought the record would reflect badly on the
church. (The castrati were males who were emascu-
lated so that their voices would retain their soprano
pitch.) Moresci became a professor of music and taught

ANSWERS

singing for the remainder of his life. The recording, made between 1902 and 1904, is still available.

☞ **A 64.**

Igor Stravinsky (1882–1971). Russian ballet producer and critic Sergey Pavlovich Diaghilev (1872–1929) once claimed, referring to Stravinsky's greed, that the "or" in Igor stood for gold.

☞ **A 65.**

The first American musical comedy was *The Black Crook.* The words were by Charles Barras and the music was assembled from popular tunes. It ran for 474 performances on Broadway in 1866. However, the first musical comedy with an original score was *Evangeline* by Edward E. Rice. It opened in 1874.

☞ **A 66.**

The first French musical, *La Révolution Française,* had its world premiere in 1973, well over a century after the Americans saw theirs. The French composer was Claude-Michel Schönberg; the lyricist was Alain Boublil. In the following decade, the two became world famous by making a musical out of Victor Hugo's *Les Misérables.*

☞ **A 67.**

Rock star Elvis Presley (1935–1977) died on August 16 and opera star Maria Callas (1923–1977) died on September 16.

MUSIC

☞ A 68.

The rock singers Jennifer Warnes and Joe Cocker. Their song *Up Where We Belong* reached number one on the record charts in the United States. Other rock singers whose songs were used in the movie were Pat Benatar, Van Morrison, and the group, Dire Straits.

☞ A 69.

The BBC banned Johnnie Ray's (1927–1990) single "Such a Night" on May 8, 1954, after complaints from listeners about the song's suggestiveness.

☞ A 70.

The English magazine referred to Frédéric Chopin (1810–1849).

☞ A 71.

It was Georges Bizet's Symphony in C Major. Bizet (1838–1875) died three months after the premiere of his last and most famous work, the opera *Carmen*. He was thirty-six years old.

☞ A 72.

The orchestra was the still renowned Gewandhaus Orchestra of Leipzig. The child prodigy sharing the program with Wagner (1813–1883) was Clara Wieck (1819–

ANSWERS

1896), soon to become a composer and one of the great pianists of the nineteenth century, as well as the future wife of Robert Schumann (1810–1856) and the mother of his seven children.

☞ **A 73.**

This was said on September 8, 1949, by Richard Strauss (b. 1864) about his tone poem "Death and Transfiguration," just before he died.

☞ **A 74.**

Wagner was referring to Franz Joseph Strauss (1822–1905), the father of the composer Richard Strauss. Franz Joseph Strauss was himself a composer, one who disliked Wagner's "modern" music. For forty-nine years, he was the principal horn player in the Munich Court Orchestra.

☞ **A 75.**

It was known as "Sauerkraut."

☞ **A 76.**

The first jazz magazine, called *Le Jazz Hot,* was published on February 2, 1935, in Paris. The editor, art director, printer (and one of the columnists) was Charles Delauney. America's *Down Beat* and *Melody Maker* already existed, but they were general-interest

MUSIC

music publications. Incredibly, the first jazz club was founded in Frankfurt, Germany, in 1935, during the Nazi regime. However, the jazz devotees maintained that you could not be a Nazi and friend of jazz at the same time. Their meetings were held clandestinely.

☞ A 77.

Arnold Schönberg (1874–1951) based his orchestral piece for strings *Verklärte Nacht (Transfigured Night,* 1917) on a poem with the same title by the German poet Richard Dehmel (1863–1920).

☞ A 78.

Even Arturo Toscanini (1867–1957) conducted the *Toy Symphony* in as late as the 1930s as a work by Haydn (1732–1809). Now it is known that the work was composed by Leopold Mozart (1719–1787), Wolfgang's father.

☞ A 79.

Flagstad (1895–1962) felt she could no longer sing the high C's adequately, and so she allowed Elisabeth Schwarzkopf (b. 1915) to sing those notes for her. They were dubbed into the recording.

☞ A 80.

Tchaikovsky was writing *The Nutcracker* while he was in the United States.

ANSWERS

☞ A 81.

In 1928, Hindemith wrote the music for Hans Richter's *Ghosts Before Breakfast,* a short German experimental film.

☞ A 82.

Ferdinand David played the first performance of Felix Mendelssohn-Bartholdy's (1809–1847) Violin Concerto in E Minor, with the composer conducting. The musical instrument David and Heifetz both used was a 1742 Guarnerius violin.

☞ A 83.

Franz Liszt (1811–1886). Liszt frequently reshaped, extemporized, and improvised on solo parts for the piano in his concertos at a later date—these reshapings are musically termed figurations. It was only after he enlarged on or prepared the musical piano "mood" for his concerto that Liszt incorporated these solo parts into a new, orchestrated piano concerto.

☞ A 84.

The original lyric (for the unproduced 1931 musical *Star Dust*) contained the line, "I shouldn't care for those nights in the air that the fair Mrs. Lindbergh goes through." But after the Lindbergh baby was kidnapped and killed in 1932, Porter changed the line to the one sung ever since: "Flying too high with some guy in the sky is my idea of nothing to do."

MUSIC

☞ **A 85.**

The French philosopher Jean-Jacques Rousseau (1712–1778).

☞ **A 86.**

The composer Felix Mendelssohn-Bartholdy (1809–1847). In 1829, when he was barely twenty years old, he persuaded the Berlin Sing-Akademie to perform Bach's *Passion According to Saint Matthew,* under his direction, with a chorus of close to four hundred voices. It was the first performance of a choral work by Bach since his death seventy-nine years earlier. Mendelssohn also can be credited with reviving Handel's music.

☞ **A 87.**

Ellington, who is better known as "Duke" Ellington (1899–1974).

☞ **A 88.**

All four operas are really one and the same: *Rigoletto* by Giuseppe Verdi (1813–1901). Originally it was based on Victor Hugo's (1802–1885) verse melodrama *Le roi s'amuse,* but because of its controversial story and the riots following its 1832 Paris premiere, Verdi retitled the opera *La maledizione di Saint-Vallier* in June 1850. When it was banned because of "the revolting immorality and obscene triviality of the libretto," Verdi and his

ANSWERS

librettist, Francesco Maria Piave, changed or omitted a few scenes, renamed its characters, and gave *Rigoletto* its premiere on March 11, 1851. Even so, the papal states did not want to be connected with this opera because of its revolutionary associations, so it was performed there in 1851 without the chorus of the people revolting against authority and under the new title *Viscardiello,* while the Kingdom of the Two Sicilies staged it in 1853 as *Clara di Perth* and in 1858 as *Lionello.*

☞ A 89.

On the Piano Concerto in A Minor by Johann Nepomuk Hummel (1778–1837). Some solo passages in the two concertos are so similar that they are virtually interchangeable. Besides Chopin, Hummel is also said to have had great influence on the early work of Schubert.

☞ A 90.

Happy Birthday to You, Auld Lang Syne, and *For He's a Jolly Good Fellow.*

☞ A 91.

Myrna Loy's (b. 1905). He was still playing her Steinway at four in the morning, totally unaware that he was already suffering from a gliobastoma, the brain tumor that was shortly to kill him.

☞ A 92.

Debbie Gibson, whose 1988 debut album, *Out of the Blue,* sold three million copies and yielded five top-five

MUSIC

singles, including the number one hit, "Foolish Beat."
She was only seventeen years old at the time.

☞ A 93.

They were the first to represent sounds in written
form—they developed the musical notation, or score.
Guido lived in the twelfth century, and his use of letters
to indicate clefs has survived to this day. The develop-
ment of a fixed musical time division was worked out by
de Vitry and Francesco Landini in the fourteenth cen-
tury. They made it possible to achieve a high degree of
flexibility in the notation of upper registers. Musical
notation actually began with Terpander in Greece, in
the seventh century B.C., but his "scores" are not appli-
cable to contemporary music.

☞ A 94.

Busoni's piano concerto (1904), one of the longest clas-
sical concertos on record, has five movements and a
male chorus. Some of the earliest program notes of the
concerto claim that the male chorus was nude but kept
off stage, out of the audience's view.

☞ A 95.

"The Last Time I Saw Paris."

☞ A 96.

Irving Berlin (1888–1989). It was the title of a song in his
popular 1950 Broadway musical *Call Me Madam*.

ANSWERS

☞ A 97.

Because the rooms in that hotel chain are all laid out the same. Charles became blind from glaucoma at the age of seven, shortly after seeing his younger brother drown.

☞ A 98.

"Love Walked In." He wrote it for the motion picture *The Goldwyn Follies* just before he died in 1937. It rose to first place on the famous weekly radio program of song hits and stayed there for four weeks after his death.

☞ A 99.

For composing the song "I'm Easy" in the 1975 film *Nashville*.

☞ A 100.

The conductor Dimitri Mitropoulos (1896–1960). The idea came as a surprise to Bernstein, who had his heart set on becoming a pianist and composer. Bernstein then seriously studied conducting under such eminent maestros as Fritz Reiner (1888–1963) and Serge Koussevitzky (1874–1951).

☞ A 101.

Yes. John Bull (c. 1562–1628), the British composer, organist, and virginal player, is believed to have composed the melody of "God Save the King" in 1619 in

MUSIC

Antwerp, Belgium. The words and tune were first sung semiofficially at Drury Lane and Covent Garden theaters in London after 1745, when the defeat of the Jacobite rebellion was announced.

☞ A 102.

Caruso regarded Gaetano Donizetti's (1797–1848) opera *L'Elisir d'Amore* as his good-luck piece because his sensational performance on February 17, 1900, at La Scala—especially his singing of *Una furtiva lagrima*—led to his London and New York debuts. He sang in it thirty-three times with the Metropolitan Opera alone, but the last of these performances had to be stopped after Act I because he was hemorrhaging in his throat. The following summer he died of cancer at the age of 48.

☞ A 103.

At the age of 37. The last opera he composed was *William Tell (Guillaume Tell)*, first produced in 1829. In fact, Rossini produced very little else except for his *Stabat Mater* in the 1830s. There were several reasons for this: He was wealthy, the 1830s marked a transitional stage in the history of opera that Rossini did not find congenial, and he grew increasingly ill. Finally, political disturbances caused him to move from Bologna to Florence and then to France, where he lived with his second wife, Olympe, from 1855 until his death.

☞ A 104.

All of them were written in French.

ANSWERS

☞ A 105.

Dohnanyi was the nephew of the anti-Nazi activist
Bonhoeffer. Christoph's father, Hans von Dohnanyi, was
active in the smuggling of Jews to safety and took part
in several attempts on Hitler's life. He was also exe-
cuted by the Nazis.

☞ A 106.

The performer-composer is the former Beatle Paul
McCartney (b. 1942), who is reputed to be worth over
$600 million. The Beatles are also the most successful
performing group ever, having sold over a billion disks
and tapes. The song that has been recorded in over two
thousand versions is McCartney's "Yesterday."

☞ A 107.

Because these famous songs were neither four in num-
ber nor among his last songs. Musicologists such as
Timothy L. Jackson now maintain that a more appropri-
ate title would be *Last Orchestral Songs,* and there are
not four but five of them. (Strauss composed other
songs with piano accompaniment at a later date.) In
1948 Strauss composed four orchestral songs and then
orchestrated his 1894 song "Ruhe, meine Seele!" which
he intended to be presented before the set's finale, "Im
Abendrot." The other three songs are "Frühling," "Beim
Schlafengehen," and "September." Strauss added his
old 1894 song to the four because, in 1948, just after
World War II ended and Germany lay in ruins, the lines

186

of the old song appeared to the composer most appropriate: "Diese Zeiten sind gewaltig,/Bringen Herz und Hirn in Not" ("These times are momentous,/They place heart and mind in need"). A year after the composer's death the four newly composed songs were published under the title *Four Last Songs,* which was chosen by Ernst Roth, Strauss's editor at the publisher Boosey and Hawkes. For some unaccountable reason, the fifth orchestral song "Ruhe, meine Seele!" was relegated to a separate category of Strauss songs. (In late 1992, the song finally took its rightful place with the original four.)

☞ A 108.

Strauss's first tone poem, *Macbeth.* He first began sketching the score in the spring of 1887 at the age of twenty-three, but no orchestra would play it and no publisher publish it until Strauss received accolades for his next tone poems, *Don Juan* (1889) and *Death and Transfiguration* (1890). Finally, in December 1891, *Macbeth* was published, and a third version of the tone poem received its premiere under the composer's baton on February 29, 1892, in Berlin. However, it was not well received by the critics because it did not conform to the description in the concert's program notes. Never meant to be a descriptive musical work, it has always been regarded with low esteem.

☞ A 109.

The irony was that the piece he recorded shortly before his death was virtually the first composition of Richard Strauss—the Piano Sonata in B Minor, op. 5—begun

ANSWERS

when the composer was sixteen years old in 1880, and revised and published when he was eighteen.

☞ A 110.

The original version of *Tannhäuser* had its premiere in Dresden in 1845, but for the production at the Paris Opéra (1861), where an opera without a ballet was unthinkable, Wagner made extensive revisions, including the addition of a ballet to the Venusberg scene. Shortly before he died, he confided to his wife, Cosima, that he thought the Dresden version generally superior (even though he felt he owed the world an even better *Tannhäuser*), but it is the Paris version that is more frequently performed nowadays.

Since the Paris Opéra performs works only in French, Verdi initially composed *Don Carlos* to a French text based upon Schiller's play, and at its premiere (1867) the first of the five acts was set in France, at Fontainebleau. This act was omitted in the 1850s Italian version (*Don Carlo*), but Verdi made further revisions in 1882.

☞ A 111

The Jew was Heinrich Heine (1797–1856). Wagner used some features of Heine's poem *Der Tannhäuser* for his opera *Tannhäuser* (1845) in conjunction with the *Tannhäuser Lied*, E.T.A., Hoffmann's story of *Der Sängerkrieg*, and the medieval poem *Der Wartburgkrieg*, even though Wagner knew that Heine's poem was a parody. Heine was one of the greatest German poets, critics, and essayists of the nineteenth century. He embraced Christianity in 1825. Franz Schubert (1797–1828), Robert Schumann (1810–1856), and Felix Mendelssohn-Bartholdy (1809–1847) set many of his poems to music.

FINE ARTS

☞ **A 1.**

In 1309, Pope Clement V (1264–1314) moved the seat of the papacy from Rome to Avignon, France, where it remained until 1377. The town was papal property until 1791. Almost six hundred years later, in 1907, Pablo Picasso (1881–1973) painted *Les Demoiselles d'Avignon* (now in the Museum of Modern Art in New York City), which many consider the most significant step in the evolution of abstract art (via Cubism).

☞ **A 2.**

There are no such paintings. His horrifying representations appear only in his drawings, like those of the

ANSWERS

Medusa with snakes for hair, bestial imbeciles, leering faces, beggars wrinkled with age, human figures literally decaying with disease. About 1,700 of them can be found in one manuscript, the *Codice Atlantico* in Milan. Leonardo deliberately kept dreadful images out of his paintings.

☞ **A 3.**

Giulio Romano (1499–1546). Besides being a painter, he also was an architect, the principal heir of Raphael (1483–1520), and one of the founders of Mannerism. In Act V, scene ii, of Shakespeare's *Winter's Tale,* the Third Gentleman tells some companions about a supposed statue of Hermione, Leontes' queen, who is believed to be dead:

> . . . a piece many years in
> doing, and now newly perform'd
> by that rare Italian master,
> Julio Romano.

☞ **A 4.**

Vincent van Gogh (1853–1890). The only painting he ever sold—for about seventy-five dollars—was called *The Red Vineyard.*

☞ **A 5.**

He considered Leonardo to be nothing but a dawdler. Michelangelo (1475–1564) didn't interest him much, either, since he cared neither for paintings on a massive scale nor for architecture.

FINE ARTS

☞ **A 6.**

On Ludwig Mies van der Rohe's (1886–1969), the leader in the early 1930s of the Bauhaus school of architecture in Germany, founded by Walter Gropius (1883–1969). Mies came to the United States in 1938 and was in the vanguard of the architectural revolution here, eventually becoming the head of the department of architecture at the Illinois Institute of Technology in Chicago.

☞ **A 7.**

Because he believed that a skyscraper would disturb the traditional unity and beauty of the city. Within days, the government endorsed his refusal with an ordinance forbidding the construction of skyscrapers in Beijing.

☞ **A 8.**

With the help of Ionian painter Parrhasius, Zeuxis was supposed to have introduced the use of highlights in shading. He decorated the Macedonian royal palace at Pella, and once painted a bunch of grapes that looked so realistic that some birds pecked at them. Another legend had it that he laughed so hard at his own painting of an old hag that he broke a blood vessel and died.

☞ **A 9.**

John Constable (1776–1837) and Joseph Mallord William Turner (1775–1831). They are frequently con-

ANSWERS

sidered the forerunners of French Impressionism, a style of painting depicting natural appearances of objects using short brush strokes of bright colors in order to simulate actual reflected light and represent the artist's immediate, overall impression.

☞ **A 10.**

It was on the Marquesas island of Hiva Oa, in the village of Atuona, that the French painter Paul Gauguin, aged 54, died on May 3, 1903.

☞ **A 11.**

Paul Gauguin (1848–1903). He was only an amateur painter until he was encouraged by Camille Pissarro (1831–1903) to give up his job in the exchange brokerage and become a full-time artist. He sold no paintings, his funds were soon exhausted, and his wife left him, taking their five children to Copenhagen to live with her family. Gauguin then traveled all over France, lived for a time with Vincent van Gogh, made a trip to Panama and Martinique, and finally settled in the South Seas. In spite of his idealized account of life in Tahiti in a book called *Noa-Noa,* he was ruined by poverty and died of syphilis in 1903.

☞ **A 12.**

Schinkel designed the military decoration the Iron Cross. Prussian newspapers publicized it for the first

FINE ARTS

time on March 20, 1813, and King Friedrich Wilhelm III (1770–1840) approved it immediately.

☞ **A 13.**

Baron Philippe de Rothschild (1902–1988) commissioned these and many other artists to design a different label each year (except in 1953) for his Château Mouton wine bottles.

☞ **A 14.**

Frank Lloyd Wright (1869–1959), the creator of what became known as "organic architecture." He was popular in Japan because he designed the Imperial Hotel in Tokyo (completed in 1922), the only large building that offered safety during the 1923 earthquake. His workshop, which was located near Phoenix, Arizona, also served as his winter home and was called Taliesin West.

☞ **A 15.**

Portrait painter and miniaturist Charles Wilson (1741–1827). Of his eleven children, Rubens Wilson became a painter of still lifes, Raphael a miniaturist, and Rembrandt a painter of portraits and historical subjects. In 1805 Charles was one of the founders of the Pennsylvania Academy of Fine Arts, and his brother James (1749–1831) had George Washington sit for him twice when he was painting his portrait.

ANSWERS

☞ **A 16.**

Edvard Munch (1863–1944), usually considered Norway's greatest painter.

☞ **A 17.**

Jean Baptiste Camille Corot (1796–1875). One reason for this vast collection was Corot's habit of correcting his students' work and then signing his own name to it. Corot also made an enormous number of small oil sketches of landscapes—including some of his finest works—which he planned to use later in large landscapes to be painted in his studio. In addition, a wholesale forgery business of Corot's work flourished soon after his death. One Dr. Jousseaume ended up with 2,414 forged watercolors and drawings.

☞ **A 18.**

After restoration, the thirteenth-century frescoes included representations of the twentieth-century Russian monk Rasputin, a German movie star, and one of the restorers' relatives. The "restorers" were Lothar Malskat and his supervisor, Dietrich Fey. These two had already forged thirteenth-century frescoes in the 1930s when commissioned to restore the almost invisible wall paintings inside the cathedral of Schleswig in northern Germany. There, they painted in several fair-haired Viking figures and four turkeys, although the latter were unknown in Europe until the sixteenth century. They resumed their criminal collaboration after the Second World War, with Malskat forging six hundred artworks

FINE ARTS

by artists from Rembrandt to Chagall and Fey arranging the sales to dealers. However, when Fey received all the credit, including the Federal Cross of Merit, for leading the "restoration team," Malskat, who had done most of the work, grew resentful, and in May 1952, he confessed that the paintings in St. Mary's choir and nave had been, to a large extent, copied from a book of medieval figures Fey had lent him. Malskat became a popular hero simply because the art historians who had gone into raptures over the "restoration" had been fooled. Although as Malskat's commissioned supervisor it had been Fey's duty to report that the crumbling frescoes in both churches could not be restored, Fey's prison sentence was only two months longer than Malskat's, who was sentenced to twenty months.

☞ A 19.

The first three painters belonged to the American Ashcan School of the early twentieth century. They painted squalid realism of city life in a bold representation of harsh, environmental truths. The most famous of these painters was John Sloan (1871–1931). The latter three artists were members of the British Kitchen-Sink School of the 1960s. In their "New Realism" style, they chose for their subjects articles associated with dustbins and kitchen sinks.

☞ A 20.

The artist was Raffaello Santi (or Sanzio), known as Raphael (1483–1520). The pope was so enthusiastic about Raphael's work that he dismissed painters who had already been decorating the Borgia Apartments

ANSWERS

with frescoes—Peruzzi, Bramantino, Lotto, and Sodoma. The pope had all their paintings removed in order to leave the space open for Raphael.

☞ A 21.

Masons showed trowels and bricks; smiths displayed hammers and anvils. The gambling houses displayed a *fritillus* (dice box), and the houses of prostitution a phallus. These emblems were usually carved from tufa, a porous limestone; a few were made of marble or terra cotta.

☞ A 22.

Michelangelo (1475–1564). Just the opposite were his Venetian contemporaries, Titian (1477 or 1490–1576), Tintoretto (1518–1594), and Veronese (1528–1588), who were praised for their ability to depict lifelike features and the flesh tones of their sitters.

☞ A 23.

Picasso's first exhibition in the United States was at the Photo-Secession Gallery in New York in 1911, right after he had started developing Cubism with Georges Braque (1882–1963).

☞ A 24.

Embarkation for Cythera by Antoine Watteau (1684–1721), which hangs in the Louvre. Even now, people cannot agree whether the human figures in the canvas are leaving for or returning from the island.

FINE ARTS

☞ **A 25.**

Henri de Toulouse-Lautrec (1864–1901). Van Gogh left Paris for Arles on February 20, 1888.

☞ **A 26.**

Il Paradiso (painted in 1587 to 1590) is the largest "Old Master" painting in the world. (However, its compositional virtuosity is considered by some to be inferior to its preparatory sketch that hangs in the Louvre.)

☞ **A 27.**

Benjamin West's (1738–1820) *The Death of Wolfe.* The British general James Wolfe died during the Battle of Québec in 1759. West first exhibited his painting at the Royal Academy in 1771. Emulating the Old Masters, West reconstructed the scene of the dying general "not as it was," he admitted, "but as it ought to have been."

☞ **A 28.**

The boast was made about the city of Rome by Caesar Augustus (27 B.C.–A.D. 14), first Emperor of Rome.

☞ **A 29.**

The Pantheon. It was reconstructed in A.D. 115 to 125 by the emperor Hadrian (A.D. 76–138) and consecrated by Pope St. Boniface IV in 609 as Sancta Maria et Martyres (now Santa Maria Rotonda dei Martiri). The Pantheon houses the tombs of Italian kings Victor Emmanuel II

ANSWERS

(1820–1878) and Humbert I (1844–1900) and that of the artist Raphael (1483–1520).

☞ **A 30.**

Edgar Degas (1834–1917).

☞ **A 31.**

Thomas Jefferson (1743–1826) was inspired by the Roman temple that is now known as the Maison Carrée in Nîmes, in the south of France.

☞ **A 32.**

No one knows why they are there. It is a question that has puzzled art connoisseurs for centuries.

☞ **A 33.**

Modern scholars believe that Titian was born around 1490. They find the 1477 date implausible because there is no documented activity by him before 1507. Around 1507, or a bit earlier, Titian probably studied with Gentile Bellini (1429–1507) and his brother Giovanni Bellini (1430–1516) as well as with Giorgione da Castelfranco (1478–1510), a celebrated Italian painter of the Venetian Renaissance. Titian was his junior collaborator on frescoes for the facade of the German merchants' building in Venice. In fact, Titian's own earliest documented works are some frescoes in the Scuola del Sant' Antonio in Padua, dated 1511, when, according to modern research, he was in his early twenties. The 1477 birth date would have put him in his mid-thirties—an age at which a man of his talent

FINE ARTS

and stature would doubtless have already created many major works of art.

☞ **A 34.**

The Einstein Tower in Potsdam, near Berlin. The observatory was built in 1920 by Erich Mendelsohn, a leading Expressionist architect.

☞ **A 35.**

Although he pioneered photojournalism in Europe, Kertész' work was rejected in the United States well into the 1960s because it was considered too formal. He died in New York in his nineties, in 1985, embittered that he had been recognized in the United States too late in life, although as many as twenty of his books had been published in twenty years and exhibits of his work held everywhere.

☞ **A 36.**

Pietro Tacca (1577–1640). Among his important works are four superb figures of Moorish slaves on the monument of Ferdinand I at Livorno. In Florence, he is represented by the fountain in the Piazza dell'Annunciata, the bronzes for the Capella dei Principi in San Lorenzo, and the *Boar* in the Mercato Nuovo. He also did an equestrian statue of Philip IV in Madrid.

☞ **A 37.**

Bellini asked his brother, Giovanni (1430–1516), to complete the canvas since he had already undertaken too much that year. When Gentile Bellini died in February

ANSWERS

1507, Giovanni completed the painting that is now known as *Saint Mark Preaching*. It hangs in the Brera Museum in Milan.

☞ **A 38.**

The title of Brueghel's 1565 series is *Months*. Some art historians think that two months are represented in each painting, others that each month was depicted separately. That's why there is a controversy today over whether the series originally comprised six or twelve pictures. One painting belongs to the Metropolitan Museum of Art in New York, another to the National Gallery in Prague, and the other three to the Kunsthistorisches Museum in Vienna.

☞ **A 39.**

The Expressionist painter Egon Schiele (1890–1918). He died of Spanish influenza in Vienna on October 31.

☞ **A 40.**

Colored butter.

☞ **A 41.**

Gustave Courbet (b. 1819), a leader of the realist movement in painting. He was a Socialist and later became an official of the Paris Commune. After the fall of the Commune, he spent six months in prison, and then

FINE ARTS

went into exile in Switzerland, where he died on New Year's Eve, 1877, at the age of 58.

☞ A 42.

Pablo Picasso (1881–1973) and Henri Matisse (1869–1954). The former would not even see the representatives of the Rockefeller architects. Matisse (1869–1954) also turned them down, on the grounds that the scale, character, and theme of the project did not agree with his style of painting. Rivera himself demurred at the notion of a competition, saying he was no longer at a point in his career where he needed to compete for work, but the fee ($21,000) and Nelson Rockefeller's diplomatic encouragement finally persuaded him to undertake the project.

☞ A 43.

When Rivera's mural was still in its early stages in March 1933, Lenin's face was dimmed by a cap. But by April the sketch on the wall bore an unmistakable likeness to the former Soviet leader. Nelson A. Rockefeller (1908–1979) asked Rivera, in a letter dated May 4, 1933, to replace Lenin's face with that of an unknown man. Rivera, a communist sympathizer, refused to do so and the mural was eventually destroyed (February 1934).

☞ A 44.

The Night Watch by Rembrandt Harmensz van Rijn (1606–1669). It is exhibited in the Rijksmuseum in

Amsterdam and its correct title is *The Sortie of the Company of Captain Banning Cocq.*

☞ **A 45.**

They were the sons of Pieter Brueghel the Elder. The son nicknamed "Hell" was Pieter the Younger (ca. 1564–1638) and his brother "Velvet" was Jan Brueghel (1568–1625).

☞ **A 46.**

The Georges Pompidou National Center for Art and Culture in Paris. On the average it has about seven million visitors a year.

☞ **A 47.**

Georgia O'Keeffe (1887–1986), according to Benita Eisler's biography, *An American Romance: Georgia O'Keeffe and Alfred Stieglitz* (1991).

☞ **A 48.**

John Singleton Copley (1738–1815) in his *Watson and the Shark* (1778). The African-American is shown throwing a line, to no avail, at Watson, who is being charged by a shark in the green waters of Havana Harbor.

☞ **A 49.**

The sport is called curling. Although the sport was added to the Winter Olympic Games of 1924, 1932, 1964,

FINE ARTS

1988, and 1992, it only served as a "demonstration" sport, in which winners do not receive official Olympic medals. Competitions are called bonspiels in Canada and the United States.

☞ **A 50.**

A few weeks later, Vincent van Gogh committed suicide (1890).

☞ **A 51.**

Fénéon christened the art movement Neo-Impressionism (also called Pointillism) after he saw *Sunday Afternoon on the Island of La Grande Jatte* by Georges Seurat (1859–1891).

☞ **A 52.**

It is the statue of the sleeping *Ariadne* and can be seen in the Vatican Museum. The sculptor of this colossal statue, found in 1503, is unknown. It shows Ariadne sleeping on the island of Naxos, after she was deserted by Theseus.

☞ **A 53.**

The artist was Masaccio (his real name was Tomaso Guidi) (1401–1428). Influenced by the sculptor Donatello (1386–1466) and the architect Filippo Brunelleschi (1377–1446), Masaccio was the first painter to apply the scientific laws of *tonal* and *linear* perspective to his craft.

ANSWERS

☞ A 54.

It was the Gothic cathedral of Santa Maria del Fiore in Florence. For a century and a half nobody knew how to close the opening, which measured 132 feet (40 meters) in diameter, over the cathedral's crossing. It was the Florentine architect Filippo Brunelleschi (1377–1446) who was entrusted, in about 1419, to construct the dome, a feat considered to be impossible by many of his contemporaries. Although he did not live to see the completion of the great cupola, this masterpiece is known to be one of the triumphs of architecture.

☞ A 55.

The artist, Sofonisba Anguissola (1532–1626?), was the only painter to forge a link connecting the artistic heritage of the Italian Renaissance with that of the English Restoration. More unusual is that Anguissola (sometimes spelled Anguisciola and Angusciola) was a woman, probably the finest female portrait painter of the Renaissance.

☞ A 56.

It was Vincent van Gogh speaking to a friend while they were looking at Rembrandt's *Jewish Bride* in Amsterdam in 1885. Rembrandt (1606–1669) completed the painting ca. 1665.

☞ A 57.

It was William Hogarth (1697–1764), the English painter and engraver, mainly popular for his satirical pieces.

FINE ARTS

The eight pictures of *A Rake's Progress* as well as the engravings of *A Harlot's Progress* in the early 1730s made him so wealthy that he was able to buy himself a large house in London's Leicester Square, in which he lived the rest of his life. When he continued to suffer from the piracy of his engravings in the mid-1730s, he secured the parliamentary passing of the statute, known even today as "Hogarth's act," to protect the copyright of original artworks.

☞ A 58.

It is one of the earliest oils ever painted: *The Marriage of Giovanni* (?), *Arnolfini and Giovanna Cenami* (?), or more popularly known in the English-speaking world as *John Arnolfini and His Wife* (1434) by the great Flemish painter Jan van Eyck (1385– or 1390–1441). The Gothic inscription by the painter on the wall above a mirror reads (in Flemish): "John van Eyck was here 1434." The fruit in the painting suggests the state of man before the fall, the dog represents domestic bliss, and the sole burning candle in the candelabra symbolizes the unity of marriage.

☞ A 59.

The critics were referring to Michelangelo's 8,070-ft. fresco in the Sistine Chapel after it had been restored (from 1980 to 1986). They accused the restorers of removing Michelangelo's darkened glue, which he had applied intentionally to dampen the fresco in order to achieve a sense of near-sculptured depth. However, other art experts, like the Kress panel, a New York–based arts and preservation group of the Samuel H. Kress Foundation, concluded that the "new freshness of

ANSWERS

the colors and the clarity of the forms on the Sistine ceiling . . . affirm the full majesty and splendor of Michelangelo's creation."

☞ **A 60.**

The Parisian painter creating his art only in the studio was Edgar Degas (1834–1917). Degas turned to sculpture and other art media in the 1880s because of his weakening eyesight. Sculpture, especially, afforded him the sense of touch. The Indépendants was the name by which the Impressionists were known in France after 1879. Degas eventually became completely blind in one eye and almost blind in the other.

☞ **A 61.**

Michelangelo's (1475–1564) tenure as architect of St. Peter's from 1546 to 1564 is misleading, to an extent. He produced few designs of the cathedral prior to construction and, as a result, mistakes were made. For example, the vault of the southern tribune had to be demolished in 1557 because a contractor had made a mistake in the curve of a soffit. Although the dome of St. Peter's was at first based on Michelangelo's wooden model (1558–1561), the outer shell, chiefly erected under the guidance of Michelangelo, had to be rebuilt because of several details, over which Michelangelo had little control, that led to faulty construction. The new dome was raised by Giacomo della Porta in 1588 to 1590 and no longer conformed to Michelangelo's plans. In addition, the dome, built only on a light drum of travertine, had to be braced with iron by the architect Luigi Vanvitelli (1700–1773). And finally, the interior of St. Peter's Basilica, including both the bronze *bal-*

FINE ARTS

dachino (canopy) over the papal altar and the papal bronze throne, was not designed by Michelangelo either, but by Giovanni Lorenzo Bernini (1598–1680).

☞ **A 62.**

When painters use distemper. This is a method of painting with water-soluble colors that are mixed with chalk and clay and diluted with size instead of oil. "Size" in this case refers to a gelatinous solution, which can be used to glaze the surface of paper. (It can also be used to stiffen fabrics and other materials.)

☞ **A 63.**

Emil Nolde (1867–1956), the founder of German Expressionism. His real name was Emil Hansen, but he thought that Hansen was too common a name and so named himself after the village of Nolde in the northern part of the state of Schleswig-Holstein, where he was born.

INDEX

INDEX

INDEX

INDEX

INDEX

INDEX

INDEX

INDEX

INDEX

INDEX

INDEX

INDEX

INDEX

INDEX

INDEX

INDEX

INDEX

INDEX